IMAGES
of America

CALISTOGA

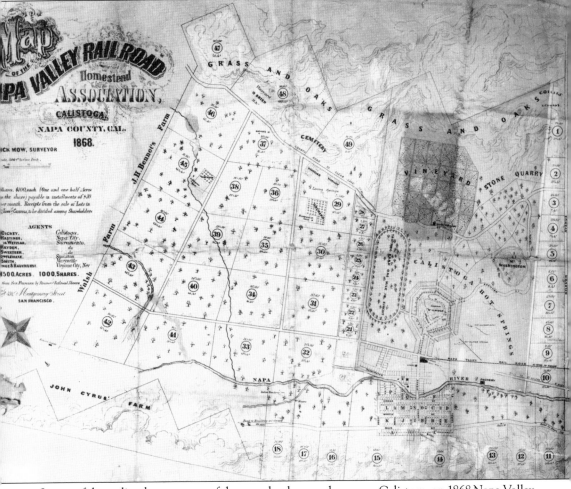

In one of the earliest known maps of the area that became known as Calistoga, an 1868 Napa Valley Railroad Homestead Association map compiled by surveyor Fredrick Mow shows Calistoga quite different than it is today. For example, Foothill Boulevard is called Main Street, and Washington Street is shown to extend to nearby St. Helena, some 8 miles away. Lincoln Avenue actually seems to circle Mount Lincoln, and a trotting park 1 mile in circuit occupies the stretch of town occupied today by Lake Street and nearby neighborhoods. The Pioneer Cemetery is nowhere to be seen. Instead, another cemetery is located along the then county road to Clearlake, between today's Zahtila Winery and today's Paradise Road. Railroad Street is Fair Way today and stretched all the way to what is now known as Tubbs Lane. Furthermore, the surveyor, who proposes to sell 1-acre shares of land for $100 each, claims the property is only three hours from San Francisco via steamer. Calistoga was incorporated as a city on January 6, 1886.

ON THE COVER: Calistoga has always been a community of contrasts, a place where rugged reality met powerful dreamers, where farmers scratched a living from the rich volcanic soils. One of the dreamers, Calistoga's heralded founder Samuel Brannan, made his dream of building the city's first resort come true here and inspired others to fashion their own dreams. Nature flourished beside commerce and the past has never been far from the present. Calistoga remains a place where yesterday is juxtaposed with today just as its frontier heritage, epitomized in a lone rider, refused to yield in this photograph taken by an unknown photographer in the early 1930s. (Courtesy of Sharpsteen Museum Association.)

IMAGES
of America

CALISTOGA

John Waters Jr. with
the Sharpsteen Museum

ARCADIA
PUBLISHING

Copyright © 2008 by John Waters Jr. with the Sharpsteen Museum

ISBN 978-0-7385-5594-2

Published by Arcadia Publishing
Charleston SC, Chicago IL, Portsmouth NH, San Francisco CA

Printed in the United States of America

Library of Congress Catalog Card Number: 2007933022

For all general information contact Arcadia Publishing at:
Telephone 843-853-2070
Fax 843-853-0044
E-mail sales@arcadiapublishing.com
For customer service and orders:
Toll-Free 1-888-313-2665

Visit us on the Internet at www.arcadiapublishing.com

This book is dedicated to all who have made Calistoga a place where the labors of its pioneers are still enjoyed.

CONTENTS

ACKNOWLEDGMENTS

Paying homage to the many people who were part of making this book a reality is possibly the most difficult task of all, for those who have contributed the most to its contents have themselves been buried by the passage of time.

The stories of Calistoga's pioneering ancestors would have disappeared long ago, lost like the droplets of diamonds that fell from their wagon wheels as they crossed the bright streams and lazy creeks that nourished the valley, were it not for people like Charlie Carroll, I. C. Adams, Elizabeth Cyrus Wright, and Martha Louisa Avery Bryant, who, in addition to being pioneers, were writers whether they called themselves that or not. The stories and photographs they left behind for new generations to discover remain proof they treasured Calistoga's youthful accomplishment as they watched it grow from the ground in a land that "lay fresh from the hand of God, like a great unfenced park," as Elizabeth Cyrus Wright wrote in 1928.

Tribute must also be paid to younger writers and storytellers, like Kay Archeleta, Dominic Triglia, Kent Domogalla, and Lin Weber. Particularly helpful was Domogalla's index of historic names and places, a remarkable compilation that is a who's who and what's what of where upper Napa Valley history may be found in print. Jack Smith, of Calistoga, generated much enthusiasm for this project, as did John Monhoff, Minnie Hunt, Ray Breitenstein, Jo Noble, and many others.

Kudos must also be given to Calistoga's Sharpsteen Museum Association, first for its willingness and enthusiastic support of this project and for granting unconditional access to their archives and facilities. Virtually all of the photographs herein were culled from their archives—unless otherwise noted, they are courtesy of the Sharpsteen. Many have never been so freely available to the public. Together with the research of generations of writers who have chipped away at lodes and pockets of history like miners of precious lore, these photographs will once again allow Calistoga's pioneers to live.

INTRODUCTION

If Calistoga was located anywhere other than the once wild Wild West, it might be called a hamlet. Although in size that may well describe the village, but "hamlet" diminishes the history that takes refuge behind the facade of the tiny downtown neighborhood—a scant city of 2.5 square miles at the northernmost tip of the world-famous Napa Valley.

Nearly surrounded by mountains, Calistoga is located some 365 feet above sea level at longitude 106.5, latitude 38.6 minutes north—about 75 miles north of San Francisco. Calistoga is easily reached from anywhere in the greater Bay Area and is an easy drive from the Sacramento area nearly 90 miles to the north. Calistoga may be reached from Interstate 80 by exiting on Highway 12 to Napa and following California State Highways 128 and 29 north through the Napa Valley, a region that, in spite of outward appearances, is only about 10 percent committed to viticulture.

To remonstrate that winemaking has been the life's blood of this place where Mount St. Helena stayed the progress of the iron horse—as *Treasure Island* author Robert Louis Stevenson wrote in his 1880s *The Silverado Squatters*—is to be considered completely ill-informed by local old-timers.

Calistoga's geological and human history began far ahead of man's ability to record it. Its unique geological history began millions of years ago, when a volcano some 20 miles distant—Mount Konocti—erupted, creating fissures deep into the earth while dropping huge deposits of ash over the entire region. The result of that ancient episode, however, continues, permitting boiling water to escape to the surface in the form of spectacular geysers that erupt generally every 15 minutes at places like the historical Old Faithful Geyser on Tubbs Lane north of town. The volcanic activity that formed the geysers and buried the region in ash also laid the groundwork for a fertile farming region and a sheltered climate between a pair of mountain ranges.

Estimates vary, but the region may have become populated by Native Americans from 500 to 5,000 years ago. Unfortunately, the Wappo, or more correctly the Ashochimi group of Native Americans, who occupied Calistoga's Hot Springs basin, had no written language, and their spoken language— similar to the Yuki spoken by native tribes in the Ukiah area—has virtually disappeared. Even so, the Ashochimi—who came to be known as "Wappo" only after American pioneers Anglicized *guapo*, a word used by early Spanish settlers to describe the natives as "brave" in honor of their resistance to Spanish civilization—passed stories and customs to their children verbally.

Long before Calistoga came to be the name of this place, the Ashochimi called Calistoga Nilektsonoma, which means "the Chicken Hawk Place." Mount St. Helena, standing over the area, was known as Kanamota, or "The Human Mountain."

Calistoga, like much of America's old west, is a land of ghosts. Little else remains of the Wappo. The likenesses contained in this volume, a Wappo man and a woman, are copies of paintings by the great pioneer artist Edward S. Curtis and are used with the permission of the creators of the Internet Web site www.firstpeople.us.

Generally referred to as hunter-gatherers of food, the Wappo lived in small groups without centralized political authority in homes built from branches, leaves, and mud. They resisted

colonization but signed a peace treaty with the Spanish in 1836. Estimates of the population of most native groups in California prior to the arrival of the descendants of European settlers vary, but generally, the population of the Wappo by the early 1800s has been estimated at 1,650. As Calistoga was taking shape in the 1850s, their numbers were reported to be between 188 and 800. Epidemics of disease—the travail of civilization's encroachment into paradise—further reduced the numbers to about 73 by the time the government counted its peoples in the 1910 U.S. Census. A few descendants are said to still live in nearby Sonoma County.

The first American pioneers began arriving Upvalley in the 1840s. Calistoga's growth followed the wholesale giveaway of land for pennies on the dollar, treacherous struggles of man against nature as he worked to tame the land, creative if not outright fraudulent bargaining, scandalous divorce, and even murder.

Some of the antecedents of today's Calistogans came over the eastern deserts and mountains, including survivors of the horrifically ill-fated George Donner/James Reed party of settlers who barely survived the winter of 1846 at what is today called Donner Pass near Truckee, California. At least one of that party, Lovina Graves, who was a dozen years old during the infamous pioneer journey, eventually made her home in Calistoga, where she and a brother, William Cooper Graves, who lived as a blacksmith in the Santa Rosa area, are buried in the Pioneer Cemetery.

Others arrived by sea through a bustling oceanside city not yet called San Francisco but Yerba Buena. From there, they steamed north, across the bay to a little town at the mouth of the Napa River that, for a while from 1852 to 1853, was known as California's state capital, Vallejo. By the 1860s, travel by stage from the Vallejo waterfront to points beyond—Sonoma, Petaluma, Napa City, St. Helena, Calistoga, Knights Valley, Lake County—ran daily.

Following the paths of the earliest pioneers, the ones who built the Upvalley's earliest businesses—the Bale gristmill, the first Upvalley house, and the first church—was California's first reputed millionaire, Samuel Brannan. Brannan, like heroes sometimes do, rent the veil of time to see that men and women of all stripes would turn Calistoga into a progressive and permanent American city.

Brannan arguably acquired much of the land and then founded what would become Calistoga only to lose half of it in a costly divorce settlement, from which he never recovered, dying virtually penniless in San Diego 24 years later. By the 1880s, famed writer Robert Louis Stevenson came along and labeled the bustling community of Calistoga a "metropolitan hamlet."

Like ancient prophets who record history for goodness sake, a witnesses or two of those early events and lifestyles of Calistogans incorporated the use of a most amazing archival tool known to humankind at the time—a precision optical apparatus known as the camera—to capture a fraction of a second of their daily lives.

In the pages that follow, bear witness to the lives of the region's newest native folk, Calistoga's pioneer people, whose tough exteriors before the camera are a road map of their passionate struggles to develop a province of their own, a little cold hard cash, opportunity, and any destiny they could imagine.

One

THE ROAD TO CALISTOGA

In her 1928 booklet "The Early Upper Napa Valley," Calistogan Elizabeth Cyrus Wright recalled stories told to her by parents and relatives as she grew up in early Calistoga. When the first pioneers made their way into what is today Calistoga, landmarks were few. A valley, framed by rugged hills to the east and forested hills to the west, were two, for example. A tall mountain in the far north and a spacious sky that emptied into the bay to the south oriented the newcomers. Like a patient museum docent, the creek-fed river that grew smaller as pioneers struggled north along a single-lane wagon trace acted as their guide.

Calistoga, like much of the valley, lay "fresh from the hand of God, like a great unfenced park," Cyrus wrote in her book, *The Early Upper Napa Valley*.

Her parents were two of Calistoga's earliest and most interesting pioneers. They endured months of tribulation on their road to Calistoga, which began in Missouri in the spring of 1846—a year of decisions for a great many Americans who chose to emigrate westward. It was the year war broke out with Mexico. Mormons were on the move, looking to situate a latter-day nation of Israel away from religious persecution in the nation's Midwest. It was the year of the Bear Flag Revolt. It was the year Elizabeth's mother, Lovina Graves, at age 12, would survive the horrific winter tragedy of the Donner Party—a wagon train of settlers who became trapped in the Sierra Nevada and resorted to cannibalism to survive. When her road started, Lovina had a mother, father, and eight siblings, one of whom was married. Before it was over, she had lost her parents, two siblings, and her brother-in-law. Elizabeth's father, John Cyrus, at 16, was spared a similar fate when he and his family crossed the Sierra ahead of the Graves family and the others. The survivors initially lived in San Jose and Napa before moving to Calistoga, where Lovina married John.

While the Graves and Cyrus families were pushing their way through the mountains that dreadful winter, the Bale gristmill south of Calistoga was already grinding out the valley's daily bread. John York had built Calistoga's first permanent building at today's intersection of Foothill Boulevard and Lincoln Avenue, but he would soon leave to soldier for the Americans of the Bear Flag Party in Sonoma.

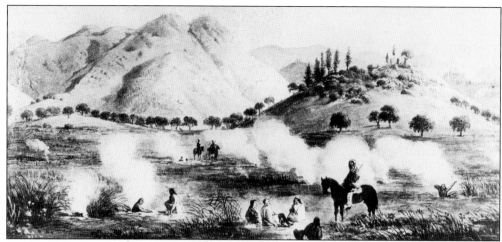

Long before there were any resorts, wineries, grain mills, and Spanish explorers, Calistoga was populated by the Ashochimi, a small group of Native Americans with no written language, depicted here in this 1870 drawing by an unknown artist. They passed stories and customs along to their children through various storytelling techniques. The Ashochimi were called "brave," or *guapos*, by the early Spanish. That name evolved into Wappo as the common language of the region changed to English.

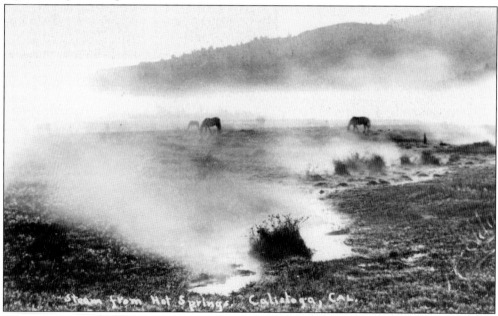

When antecedent Calistogans first arrived at the area in the mid-1840s, the flat grounds not far from the center of town may have well looked like this undated photograph taken by Ira Clayton Adams, the historian/photographer of Calistoga. He was known as I. C. Adams, or "Bert" to most of his friends. He photographed Calistoga from shortly after the 1901 fire until he retired in 1950. He passed away on August 21, 1960, and rests in the Pioneer Cemetery. Horses grazing amid clouds of steam and pools of water calls to mind one of the region's early names, "Water Coming Up Village." Calistoga's Native Americans had other words to describe the area that had been their home for between 500 and 5,000 years. One was Nilektsonoma, or "the Chicken Hawk Place," and "Tu La Halusi," which is to say, "a beautiful land."

In more than 2,000 photogravure plates, early American photographer Edward S. Curtis captured the traditions and lifestyles of 80 Native American tribes in *The North American Indian*, a body of work that fills 20 volumes. Tribes and cultures from the Great Plains, the Great Basin, the Plateau Region, the Southwest, California, the Pacific Northwest, and Alaska are in Curtis's images. Curtis's books were issued in limited edition from 1907 to 1930 and still influence the image of America's native people in popular culture. These images, of a man and a woman belonging to the Wappo tribe, are two of the few images of Calistoga's native people available. It is well documented, however, that numerous Wappo tribes claimed specific areas of the valley and lived on roots and berries of the region, fished and hunted, and wove baskets that could hold water.

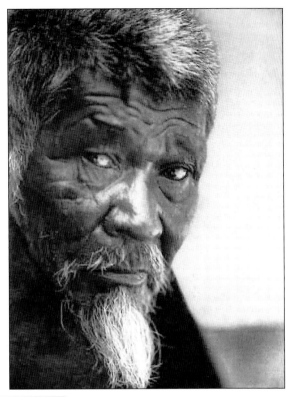

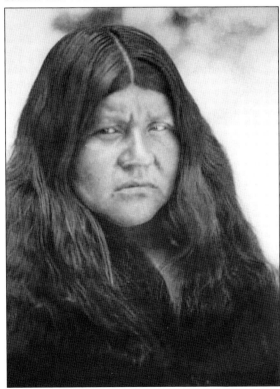

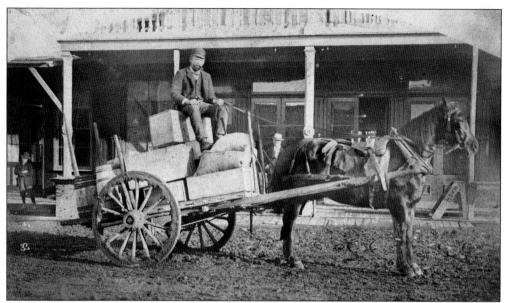

In the early 1820s, Calistoga got its first European names. A Catholic priest known as Padre Jose Altamira called the area Agua Caliente, or "hot water." Altamira had traveled the region to determine a location for the last of the church's campaign to establish a string of missions, a colonization of California that began around 1700 in Baja, California, and grew northward. The final mission was in Sonoma. The uppermost area of the Napa Valley became known as Rancho Carne Humana, believed to be a derivative of a variety of unwritten Native American names. The name, which literally means "human flesh," is thought to have been the end result of Dr. Edward Bale's attempt to write down a word based on its pronunciation. The name stuck and was officially recorded in the 1880s. By 1839 though, Bale, an Englishman who had become a Mexican citizen, was granted the region, 18,000 acres that stretched from below today's St. Helena to the foothills of Mount St. Helena. After that, others came, sometimes on foot, sometimes in little carts like this one driven by Fred Higgins in 1890.

While Lovina and her family were making their way across the plains from Missouri and over the rugged mountains, Dr. Edward Bale had set about establishing the first real Upvalley businesses: the Bale gristmill to grind the wheat and corn he expected farmers to grow once they arrived and a lumber mill near the Charles Krug winery in St. Helena so the newcomers could build homes. But it was Bale's widow, Maria Ignacia Soberanes de Bale, who ultimately built the businesses and forged their reputations.

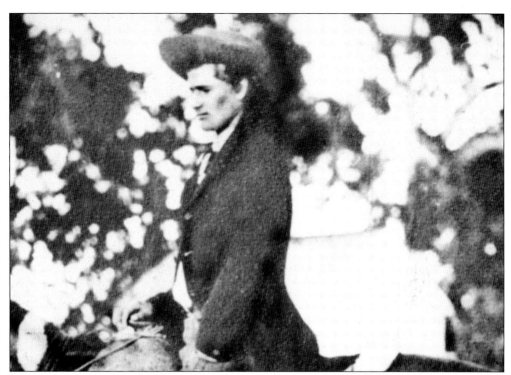

After becoming a naturalized citizen of Mexico and marrying into the family of Gen. Mariano Vallejo, Dr. Edward Bale, a former Englishman, was granted a little more than 19,000 acres, including all the land from a point just below today's St. Helena to the foothills of Mount St. Helena. Much of the land he parceled out to those who helped him establish the mill near Calistoga and a lumber mill near today's Peter Mondavi's Charles Krug winery. In 1848, a couple of years after he created the enterprise, Bale ditched the Napa Valley and went in search of gold near Sacramento. He is said to have contracted a fever then, from which he never recovered, dying on October 9, 1849, at the age of 38. The widow, Maria Ignacia Soberanes de Bale, was left to manage the great estate. Maria and her family kept the mill and hired Leonard Lillie to improve operations in 1850. He installed the present 36-foot overshot wheel, built a conveyor system, and developed a bolting and threshing machine. (Courtesy of Bothe State Park.)

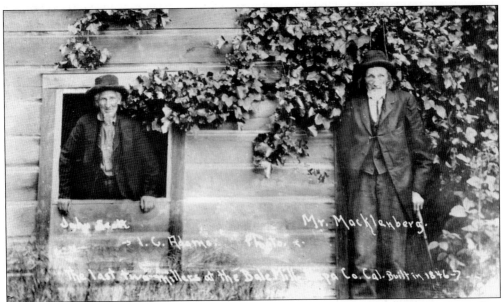

In 1860, the Bale family sold the mill, but three years later, a two-year drought hit. Struggling to remain efficient, the owners installed a steam turbine but sold the enterprise to William T. Saward, who in 1871 sold it and the surrounding land to the Reverend Theodore Lyman for $10,000. Competition from other, newer mills eventually proved too much, and the mill was used commercially for the last time in 1905. Years later, photographer I. C. Adams (a neighbor to one of the two last millers, Mr. Macklenberg) hired a team of horses and took Macklenberg and the other miller, Jehu Scott, back to the mill one last time to photograph them. Two weeks later, Mr. Macklenberg passed away, and nature nearly reclaimed the mill. Sarah A. Lyman deeded it to the Native Sons of the Golden West in 1923. The group's president, Bismark Bruck—a grandson of Dr. Bale—and the Native Sons Historical Landmarks Committee restored the mill; it became a dedicated historic site on June 1, 1925.

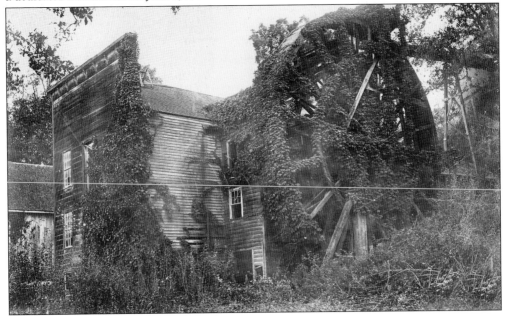

Land, food, natural resources, and gold attracted many, but for some, like Asa White, the land was filled with people whose souls needed saving. White was the second minister to preach in the Napa Valley and the first to preach in the Calistoga area. In 1852, White preached in a tent in a redwood grove donated by Reasin Tucker, another former member of the Donner Party who had left the main wagon train before the disaster. A commemorative marker was eventually placed inside the Bothe State Park identifying the site where the White Church stood. It was small, 22 feet by 32 feet, and had two separate entrances for men and women, who sat on separate sides of the church. Bale and Tucker had not signed an agreement for the land before Bale died and Tucker eventually quit claimed title to the land. Following a fascinating series of court battles, the property landed first in the hands of the Bothe family then the Coit family. The latter eventually sold the property to the state. The church burned in 1906.

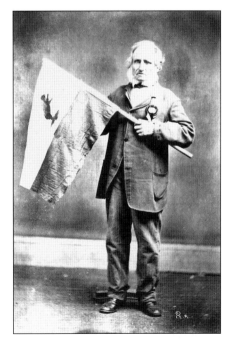

While pioneers were coming over the mountains toward Calistoga and Dr. Bale was establishing businesses to support them, others were concerned about the political future of the new communities being built. One was Peter Storm of the fledgling town not yet known as Calistoga. He and others, including the man who built the town's first house at the intersection of today's Foothill Boulevard and Kortum Canyon Road, John T. York, were gearing up to soldier for Americans during the Bear Flag Revolt in 1846. Some credit Storm, an old sailmaker, with sewing the flag in Calistoga. It was made from two petticoats, one red and one white. The petticoat donors are unknown. It was taken to Sonoma where, after General Vallejo hauled down one Bear flag (allegedly sewn in Napa), Storm's was sent back up the flagpole to declare the new republic. The bear is standing erect, and there are no words sewn on the flag. Storm, who dropped dead on Lincoln Avenue when he was 78, requested the flag be buried with him.

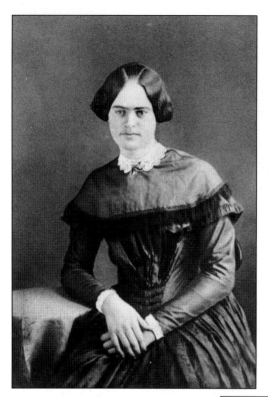

Lovina Graves Cyrus, at age 12, was one of several survivors of the ill-fated Donner Party, a large wagon train of pioneer settlers who came from the Midwest over the great Sierra Nevada in 1846–1847. She is likely the most celebrated of Calistoga's early pioneers probably because she survived the harsh conditions that forced some members of the party to cannibalize the dead in order to survive. She lost parents Elizabeth and Franklin Ward Graves, two of eight siblings, and a brother-in-law to the ordeal. Her own deceased mother was found partially eaten and with Lovina's little brother holding her and crying, according to accounts.

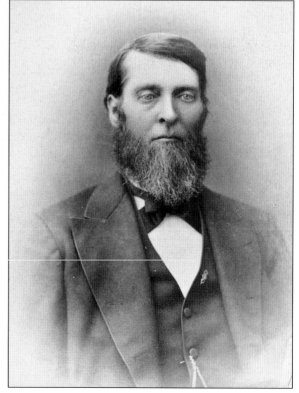

John Cyrus married Lovina nine years later. He was 16 in 1846 and went ahead of Lovina's party with his family to survive. Seven years later, smallpox wiped out most of the Cyrus family, and the two married and moved to Calistoga, where they lived happily. Her brother William became a blacksmith in Santa Rosa. All rest in Calistoga's Pioneer Cemetery. John died in 1891 and Lovina in 1906. They had three daughters: Mary Sherwood, Grace Crouch, and Elizabeth Wright.

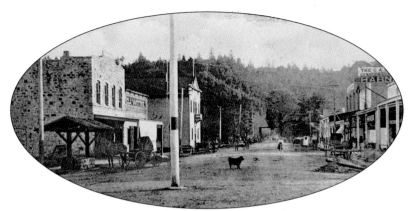

Within 40 years of its discovery, development of the region that would gain the peculiar name of Calistoga blew in with almost gale force. By the 1860s and 1870s, it was being billed as a great place to visit and written about by one of the world's great writers, Robert Louis Stevenson, in the 1880s. The wall hanging in this undated photograph shows early Calistoga. There is a watering trough for the horses to the left and a flagpole in the intersection of Lincoln Avenue and Washington Street. The view looks westward. The original Mason's Hall is on the left, next to the blacksmith shop. Look closely and see the square structure in the center of the street in the background. That is the framework for the bridge over the Napa River.

More and more pioneers moved Upvalley. Their homes sprang up beside the trail that would eventually become known as Highway 128. They used building materials readily at hand or lumber cut from Ed Bale's mill near where Charles Krug would build the valley's first winery in 1861 on land he had gotten as a dowry when he married one of Bale's daughters. This undated photograph identifies Sadie Cole with her mother and father as they sit on the porch of their home near the thickly forested Paradise Park, variously owned by Ren and Al Bothe and the most famous San Francisco female firefighter, Lillie Hitchock Coit, after whom the Coit Towers in San Francisco are named.

17

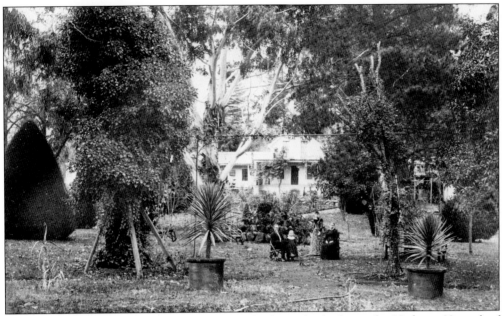

The bucolic image of sitting in a front yard beside the trail, which is today Highway 29 south of town, masks the hazards of living in the Upvalley as Calistoga started to take shape by the late 1840s and early 1850s. A tale was told about a determined bear with a fondness for hog meat. One particular night, according to writer Elizabeth Cyrus Wright, her grandmother, Lovina Graves, was staying in the middle of the valley at her sister's house beside today's Highway 128, possibly near Dunaweal Road. The family allowed a hog to live between two trees in the front yard, "where it was safe." One night, a grizzly attacked the hog and chased it around and around the house. Each time it came by the door, the women (the men were away) screamed and yelled, hoping to frighten the bear away. The pig finally tired out, and the women had to endure the sounds of the bear's feast. All the women were taught to load, shoot, and clean muzzle-loading rifles, as they never knew when some need for protection would occur.

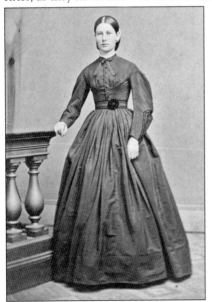

A community was growing, but by 1849—a big year for California—the newcomers weren't just coming in on wagons, they were being born here. Sarah Owsley Holton was heralded as the first white person born in Calistoga. According to legend, Sarah was born in a log cabin where Foothill Boulevard and Lincoln Avenue would intersect years later. Her birth date was December 24, 1849. Her parents were Henry and Frances Cyrus Owsley. Henry was named justice for the Hot Springs Township in 1863.

Two

OUT OF THE FOREST

Destiny was the biggest speculator of the Hot Springs territory, as the Calistoga area was known at the time. Residents often opened their doors to others making their way north. When Lovina Graves Cyrus's future in-laws made their home near the place where Highway 128 intersects the Petrified Forest Road today, the community's first neighborhood was established and the first Upvalley white child had been born. By 1849, the neighborhood was a "lineup of permanent homes along the age old trail beside the western hills," according to Elizabeth Wright's historical account of the early days of the territory.

Kellogg's Mill, also known as Bale's mill, in the south was the first stop on the trail of homes, then the Tuckers' home. The Dunaweal Road location (where the builders of Bale's sawmill constructed homes on land Bale gave them in exchange for work) was next, followed by the Calistoga corner where three homes were built and the Cyrus homestead a mile north. The name of this stretch of the trail was changed from Main Street to Foothill Boulevard by Calistoga's board of trustees in 1948.

Although the Wappo had known about them for centuries, the famous grizzly bear hunter William Bell Elliott, who came from North Carolina to the Napa Valley with his sons in 1845, discovered the local geysers in 1847. Because there were so many steam vents in the area, he said he had arrived at "the gates of hell."

Ten years later, the first proper school for the region's kids opened at the home of Henry Fowler a little west of where the Calistoga train depot would be built.

Another discovery that helped shape Calistoga as a popular destination was that of a so-called petrified forest some 4 miles into the hills west of town. "Petrified Charlie" Evans, a "brave old white-faced Swede," wrote Robert L. Stevenson in *The Silverado Squatters*, discovered the stone trees in 1870 and charged Stevenson a half-dollar to see his discovery.

It took Samuel Brannan's discovery of the Hot Springs territory, however, to really set things in motion.

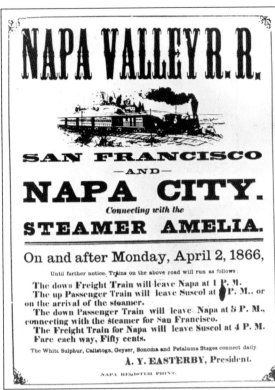

Getting folks to come to Calistoga after he arrived in Yerba Buena in 1846 took Samuel Brannan somewhat less than 20 years. When Sarah Owsley was only eight, in 1857, Brannan bought the Hot Springs property—about 2,000 acres—from the widow of Archibald Ritchie, a New Jersey man, for $10. It was listed as tax delinquent in 1858 and sold for $140 to a Napa man, who later sold it back to Brannan for $10,000! By 1861, Brannan had built the main Hot Springs Hotel Building. A year later, the resort opened with about 25 five-room cottages.

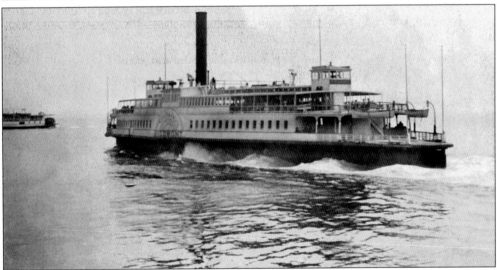

Although this model steamer ferry came along much later than the 1860s, travelers from San Francisco to Brannan's resort in Calistoga had to catch a ferry similar to this one and travel roughly three hours to Vallejo in the very early days. From there, it was about a six-hour trip by stage to Calistoga—three or so hours from Napa. The trip by train, which Brannan and partners would build, was quicker. Brannan and his partners, unknown area business and civic leaders, formed the Napa Valley Railroad (NVRR) in 1864 and started laying track then. It reached Calistoga by August 1868. The fledgling railroad became part of the Southern Pacific rail network after California Pacific bought the NVRR the next year. Calistoga's depot is now a designated state historical site (No. 687).

Samuel Brannan was a Mormon, deceiver, dreamer, entrepreneur, and many other things to many people. One historical writer claimed he deceived the U.S. government into paying for the passage of some 250 Mormon settlers to the seaside town not yet named San Francisco in 1846. He is often credited with helping to put Calistoga on the map. The tale most often told of Brannan in Calistoga today is the manner in which the town earned its unique name. During a dinner party in 1866, he attempted to boast that he would turn his resort town into the Saratoga of California. Instead, his lips, lubricated by brandy from his own distillery, boasted he would make it the Calistoga of Sarafornia and the name stuck—that's how Calistoga got its unique name.

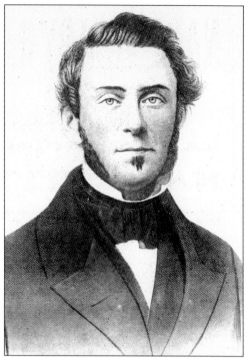

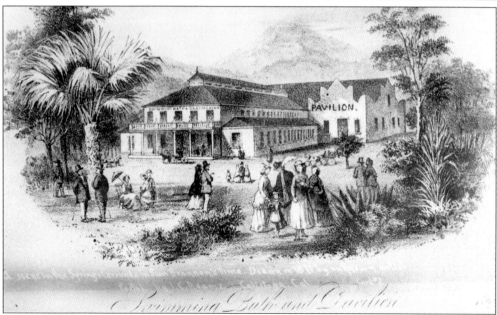

It is virtually impossible to know when Samuel Brannan first began to advertise his hotel and resort, even though he had been positioning to make a play to develop the upper valley for several years. He first bought the 2,000 acres of Upvalley Hot Springs property in 1857 from a widow for $10 before losing it a year later when it became a tax delinquent property, thus he sold it to a Napa man for $140.34. Brannan later bought the property back from that man for $10,000. By 1859, he had begun construction of his Hot Springs Resort. This picture, one of two that have survived the passage of time, was drawn by an unknown artist in 1871.

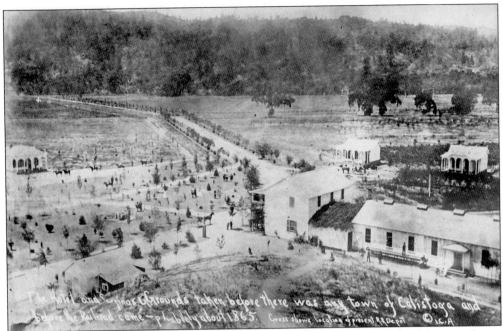

The hotel and Springs Grounds taken before there was any town of Calistoga and before the Railroad came – probably about 1865. Cross shows location of present RR Depot ©IS/A

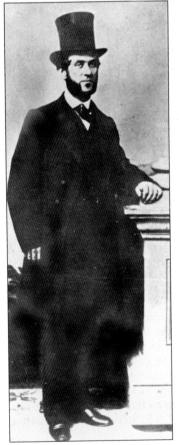

Probably the earliest available photograph of the area that would become Calistoga, this 1865 image shows the heart of Brannan's dream, the Hot Springs Resort, before there was any town of Calistoga. The hotel and pavilion are at the right with a few of the gingerbread five-room homes. Off in the distance to the left, the photograph's developer placed a tiny cross to indicate the approximate location of the train depot, which came along about three years later.

In his book *The Year of Decision: 1846*, Bernard DeVoto described Brannan as so dull looking that he often tried various combinations of beards and sideburns to give his appearance some sort of congeniality or appeal. Here Calistoga's leading man looked a little like Pres. Abraham Lincoln, although by the time Brannan's Hot Springs Resort was under construction, Lincoln had been dispatched by John Wilkes Booth. Also by this time, Brannan, attracted by the accumulation of wealth and dissatisfaction with the Mormon bureaucracy, gave up the faith.

By the early 1870s, Calistoga, as the town was called by then, was building momentum as a growing community. Not long after this illustration by an unknown artist was completed in 1871, one of Scotland's greatest writers, Robert Louis Stevenson, would label Calistoga a metropolitan hamlet. This picture is a kind of close-up version of the photograph below.

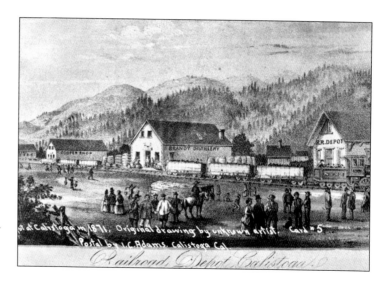

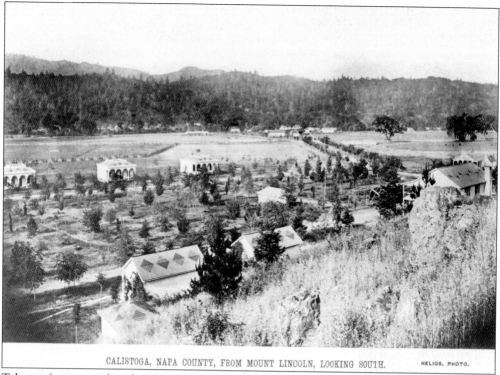

CALISTOGA, NAPA COUNTY, FROM MOUNT LINCOLN, LOOKING SOUTH. HELIOS, PHOTO.

Taken a few years after the photograph on the opposite page, this one shows the Hot Springs resort—still from Mount Lincoln but from a slightly different angle. Note that where the white cross was in the previous photograph, there is now the long building that is the train depot and a cluster of buildings across the field. By the time this picture was taken, Brannan had misspoken his resolution to make his town the Saratoga of California and this part of the Hot Springs territory had become known as Calistoga. It would still take almost 20 years for the city to incorporate into a community, but it was around this time that the community 8 miles to the south, St. Helena, would incorporate on March 24, 1876.

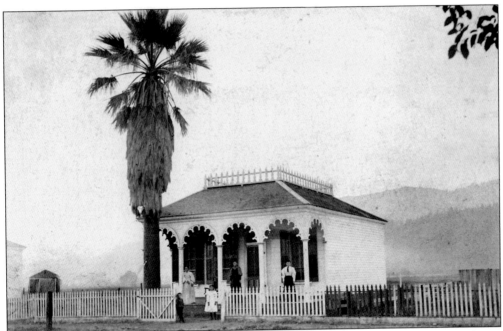

When Brannan opened his resort in the early 1860s, it included the main hotel in 1860, but it was followed with 25 of these small cottages, which he sold to private parties as summer retreats. The homes, referred to as Sam Brannan cottages today, each had five rooms and a veranda. The exteriors varied somewhat, from those with scallop-trimmed eaves to some with mansard roofs and gingerbread style. The best example of these homes exists at 1311 Washington Street today, owned by the Sharpsteen Museum Association. It is stocked with antiques from Calistoga homes.

At all of the cottages Brannan built, he also planted a palm tree, except for one privately owned home. The avenue of homes and their palms led to the front lawn of the original resort mansion, and eventually the avenue became unofficially known as Palm Row. Later, after Brannan lost ownership of the resort and it was sold to Jacques Pacheteau, a "junk dealer" was hired to sell the homes and they were all moved. Writer Robert Louis Stevenson wrote about the buildings in *The Silverado Squatters*.

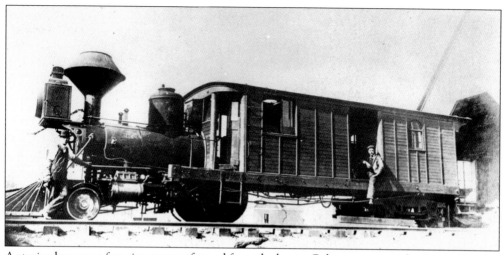

As trains became a favorite means of travel from the bay to Calistoga, a special train car like this was used to service the tracks. It was a combination engine with an attached sleeper car to house the repair workers when they moved from location to location. This engine was used to service the streetcar tracks in San Francisco before being brought to the Napa Valley.

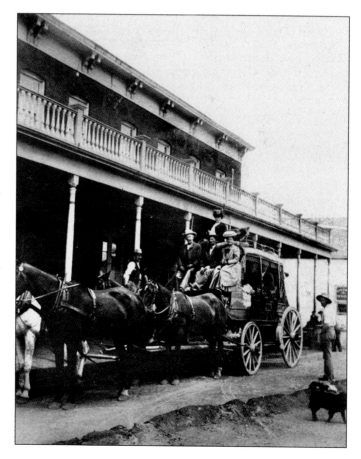

As much a symbol of the Old West as the smoke-spewing trains was the stagecoach, another favorite means of arriving at the metropolitan hamlet of Calistoga. The town, after all, was located at the frontier, where Robert Louis Stevenson wrote, "Mount St. Helena stayed the iron horse and Lake County was the frontier—the land of the stagecoach and the highwayman, like England 100 years earlier." The stage in this early-1890s picture was one of several owned by one of Calistoga's most colorful personalities, William Spiers.

William Spiers arrived in Napa County as a woodcutter before he went to Sonoma County to mine quicksilver. He saved $1,040 and staked himself as a freight hauler to the Oathill Mine near Calistoga and mines in Lake County. By 1888, Spiers, whose favored response to virtually any greeting was, "Finest kind," purchased the stagecoach line from Calistoga to Lake County and beyond. He built the stage lines into some of the finest in the region.

This Washington and First Streets property started life near the home of M. Selas Friedberg, builder of the first general store and owner of the first private telephone in Calistoga. It went through several incarnations and sales and became Piner's Hot Springs around 1914. The Spiers Stables came along in the early 20th century. After 1925, it was removed to make room for a grand entrance to the Piner's Hot Springs. That structure was eventually removed to make room for the modern Roman Spa.

Before Spiers, another driver was taking passengers through the Knights and Alexander Valleys to the geysers in Sonoma County. Clark Foss drove the first coach and six-horse team to the geysers in 1863. He was so good at directing his animals that the younger Spiers once told a researcher that Foss "could handle six horses like you'd handle that many cats." The first private phone line in Calistoga went from Calistoga's first store, co-owned by Henry Getleson and Morris Friedberg, to Foss's home near the geysers in case arrivals in Calistoga wanted fare to the geysers.

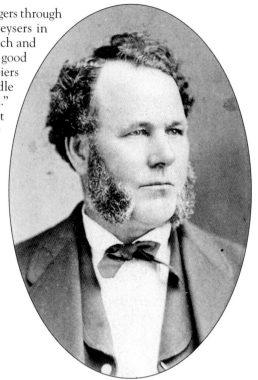

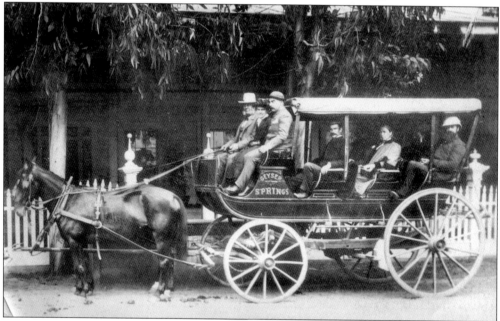

Sitting up front with the stage driver always made for an exciting ride, especially when the driver was Clark Foss. His trips into Knights Valley, Alexander Valley, and beyond from Calistoga were along trails hewn with steep cliffs on one side and immense drops into rugged canyons on the other. The fact that there were few reported mishaps testifies to the skill of the great reinsmen of early Calistoga.

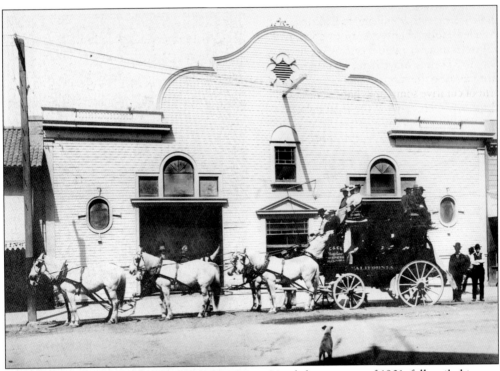

Until the summer of 1901, folks piled into or onto Spiers stagecoaches at his livery and blacksmith shop here, located where the Bank of America is today (1429 Lincoln Avenue), for trips to various cities, mostly in Lake County. This building was directly across the street from the grand three-story Magnolia Hotel. It burned to the ground 30 minutes after a fire that destroyed most of downtown Calistoga exploded from the back room of a nearby business. Spiers and his men managed to save the horses, but the stable and the rest of its contents were completely consumed.

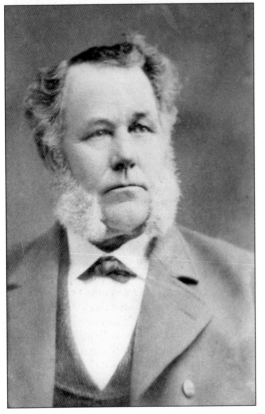

An older Clark Foss sat for portraits in the same clothes he wore driving passengers from Calistoga to the geysers in Sonoma County. He came to Calistoga in the early 1860s, invited by Brannan. When the first telegraph went up locally in 1867, and later when the first private telephone line was brought to town, lines were run to his home near the geysers. He also built the old Fossville Hotel in Knights Valley.

There were those who came to Calistoga and provided a form of entertainment combined with salesmanship. The traveling medicine men, like Franch Mayo here, would spin a yarn hawking the magical properties of some form of curative sometimes called snake oil. These men were some of the most colorful characters to travel through the little towns of the new West, including Calistoga, in the late 1880s.

C. E. WATKINS' ART GALLERY,

"Grandpa" Milton Sherwood once lived on the small ranch behind the filling station at Petrified Forest Road and Foothill Boulevard, where the original Cyrus family pioneers settled. He was married to Sarah Ann Pease. It was on the side of a barn on Sherwood's ranch where the hide of the biggest bear ever shot in Calistoga was stretched. A relative of Sherwood's, Pleasant Cyrus, shot the bear known as "Hog Killer" after it climbed a tree to escape the Cyrus family dogs. He shot Hog Killer from a nearby tree as men handed him a rifle after each shot. The bear's hide had 28 bullet holes in it.

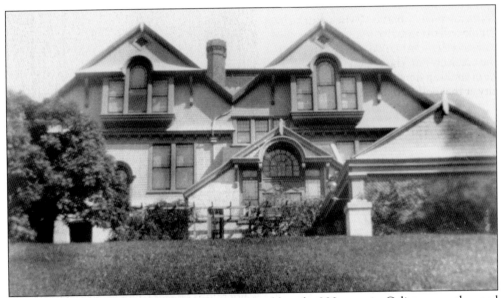

Alfred Tubbs arrived in San Francisco in 1850 and bought 900 acres in Calistoga on the road that would eventually be named in his honor, Tubbs Lane. He soon began planting vineyards (in 1880) on the property and created a winery that, nearly 80 years later and under new management, would produce some of the world's most famous wine.

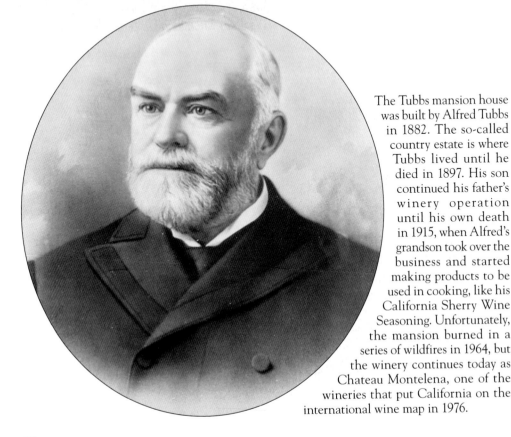

The Tubbs mansion house was built by Alfred Tubbs in 1882. The so-called country estate is where Tubbs lived until he died in 1897. His son continued his father's winery operation until his own death in 1915, when Alfred's grandson took over the business and started making products to be used in cooking, like his California Sherry Wine Seasoning. Unfortunately, the mansion burned in a series of wildfires in 1964, but the winery continues today as Chateau Montelena, one of the wineries that put California on the international wine map in 1976.

For many years, Charlie Merrick watched people and cargo arrive and depart Calistoga from his unique perspective as the conductor on the Southern Pacific train running from Vallejo to the growing city at the foothill of Mount St. Helena.

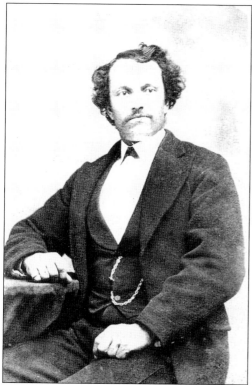

Ephraim Light was one of Calistoga's earliest wine growers. His winery was on Grant Street across from where the Palisades High School is located today. The building, which serves as a storage facility today, was once a stable built in 1859 by Sam Brannan. Across the street, about where the high school building and the Monhoff Teen Center are, is a carriage house, which burned in 1890. From this building, a man, whose name was not recorded, tried to fly in his hand-built flying contraption sometime in the early 1900s. Light also discovered one of downtown's early geysers on the Grant Street property.

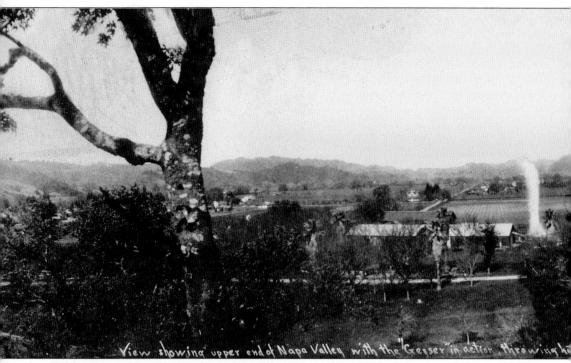

View showing upper end of Napa Valley with the "Geyser" in action throwing h[...]

Taken close to 50 years after the geysers were discovered in 1847 by famous grizzly hunter William Bell Elliott, one of Calistoga's geysers (this one located on property owned by Ephraim Light on Grant Street) shoots water and steam high into the air not far from downtown Calistoga. This geyser was eventually capped. Water at Calistoga's geysers is heated by the earth's magma, nearly

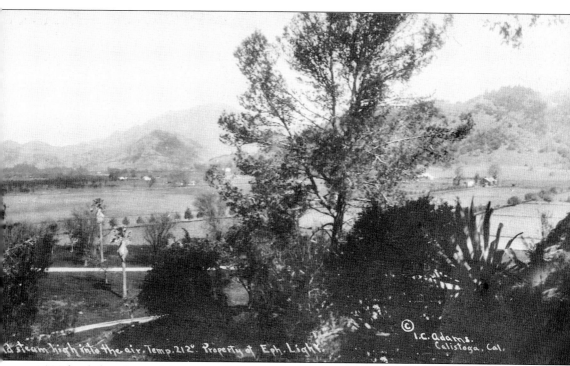

...steam high into the air. Temp. 212° Property of Eph. Light

© I.C. Adams. Calistoga, Cal.

4,000 feet below the earth's crust, and shoots out of the ground at about 212 degrees Fahrenheit. Most of the geysers have been capped today, but the Old Faithful Geysers on Tubbs Lane can still be seen as they erupt about a mile north of downtown.

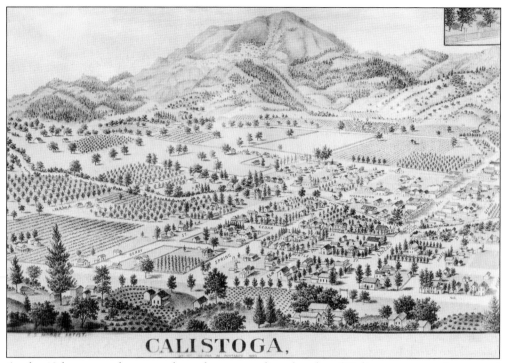

CALISTOGA,

As the 19th century drew to a close, the metropolitan hamlet of Calistoga grew and grew, and as this 1888 rendering of the community by artist E. S. Moore suggests, the encroachment of civilization was well managed by the newcomers. When Luther Burbank, a Santa Rosa–based world-famous horticulturist of the day, traveled trough Calistoga around 1916 or so, he declared favorably that Calistoga had become a thriving community. He also declared that the last time he had been through Calistoga, some 40 years earlier, Lincoln Avenue was just a cow trail.

William F. Fisher came to the Napa Valley in 1857. He built and owned the Calistoga Water Works, which he sold to the town for $40,000 in 1918. I. C. Adams was the city clerk at the time. One of his homes became the Pink Mansion Bed and Breakfast. It was a simply spectacular home built in 1873 on Main Street, which is Foothill Boulevard today.

After being rescued from a fire at age eight, Lily Hitchcock became known as Firebelle Lillie. At 15, she was riding as an honorary member of the Knickerbocker No. 5 Engine Company in San Francisco. She proudly wore a uniform she had tailored in Paris, France, complete with a badge. She played poker like a soldier, drank bourbon, smoked cigars, and played banjo while the firefighters sang along. Clarke Foss even taught her to drive a team of six horses. Lily Hitchcock Coit eventually married and then divorced Howard Coit. The couple bought land Upvalley, near Larkmead Lane in what is today Bothe State Park. As much as she adored living on Larkmead Lane, she left the area in 1887 forever to reside in Europe. She died July 22, 1929, leaving a reported $100,000 to build the world-famous Coit Towers and a statue of firemen to honor Washington Square firefighters.

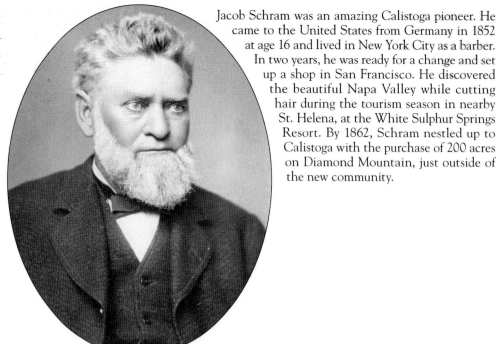

Jacob Schram was an amazing Calistoga pioneer. He came to the United States from Germany in 1852 at age 16 and lived in New York City as a barber. In two years, he was ready for a change and set up a shop in San Francisco. He discovered the beautiful Napa Valley while cutting hair during the tourism season in nearby St. Helena, at the White Sulphur Springs Resort. By 1862, Schram nestled up to Calistoga with the purchase of 200 acres on Diamond Mountain, just outside of the new community.

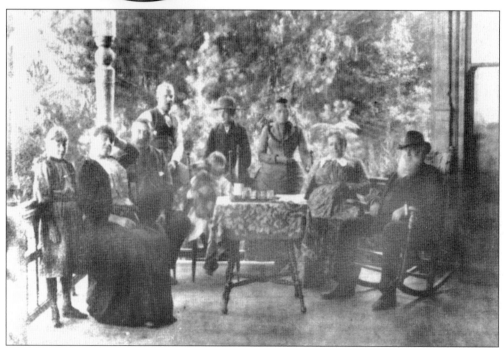

By the 1880s, the lives of Jacob Schram, his wife Annie, and their children had taken an incredible turn. The barber had become a successful vintner, producing about 6,000 cases of wine a year. Here he rests with his family on the veranda of their Victorian mansion, built on hillsides laced with tunnels described by Robert Louis Stevenson as "dug into the hillside like a bandit's cave." Chinese laborers dug them.

Could it be that the winemaker Jacob Schram enjoyed a quiet nap after testing some of his wine vintages? In 1901, his wife, Annie, died. In 1905, the immigrant barber turned winemaker became ill and also died, and his son Herman inherited the property. But an aphid infestation and Prohibition ended the Schram era. The winery went through the hands of several investors and is today again selling world-famous wines.

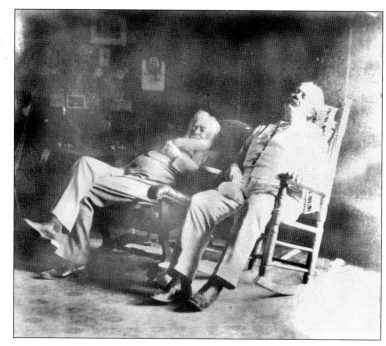

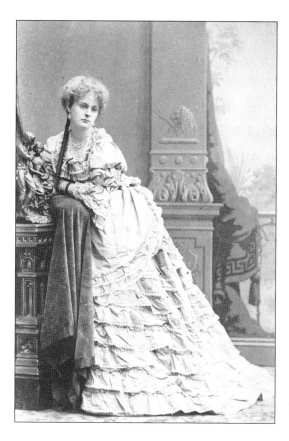

Sara Adelaide Badlam is remembered as the niece of Sam Brannan, the town's founder. Her uncle gave her a gift of land. She married Joseph W. Winans, and together they had a son, Joseph Jr. It was Sarah's brother, Alexander Badlam, who built Silverado City, a small silver mining town on the side of Mount St. Helena. Later the abandoned town was home to squatter Robert Louis Stevenson. Her family also ran a local opera house that burned in the fire of 1901.

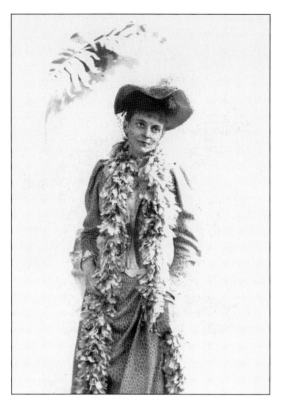

Another elegant image of Calistoga's early ladies is this 1890s shot of Lillie W. Winans. It is noted on the back of this photograph that she was another niece of Sam Brannan, which makes her a relative of Sarah Badlam on the previous page.

This is the only known photograph of little Joseph Winans Jr., the son of Sarah Adelaide Badlam. Uncle Sam Brannan was generous with the land he had purchased in the Hot Springs territory, which later became Calistoga, giving a portion to young J. W.'s parents before the boy came along.

Robert Louis Stevenson, seen here as he might have looked when he was in Calistoga as a late-20-something man, was not yet famous. The writer spent a year in the upper Napa Valley, but he was barely noticed by the people of the day. He was just 29, sick, and nearly penniless when he arrived in the United States. In California, he married the newly divorced Fanny Osbourne in San Francisco before coming to Calistoga. While here, the honeymooners lived a few months in what remained of Silverado, a small abandoned mining town on the side of Mount St. Helena built by Sam Brannan's brother-in-law, Alexander Badlam.

While in Calistoga, Stevenson wrote *The Silverado Squatters*, a journal that covers his 1880 arrival in Vallejo by steamer, the trip by iron horse to Calistoga, and the two months he spent at the abandoned Silverado Mine. The book provides descriptions of his local adventures and includes literary portraits of the people of Calistoga. It was published in 1883. Asked if he was familiar with Stevenson, stage owner Bill Spiers barely recalled him and apparently told an interviewer that if he had known Stevenson would be a famous writer, he would have paid more attention.

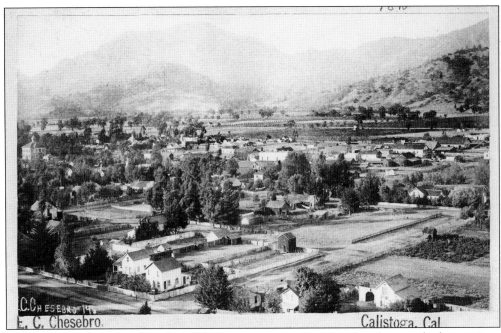

E. C. Chesebro. Calistoga, Cal

A decade after Stevenson described Calistoga as a metropolitan hamlet, the town had grown into the community seen in the 1890 photograph above and in the photograph below, taken a dozen years later. The photographs were taken from a hillside above Main Street (Foothill Boulevard today), near Pine Street. Both pictures include the two-story grammar school at the very left, and straight across to right side is the Calistoga depot. In the very middle of the picture below, the building that is the Hydro Grill downtown today can be seen, with the Spiers Stable building right behind that. To the right of center is the new, two-story Hotel Calistoga, built over the foundation of the three-story Magnolia Hotel, which burned in the 1901 fire. The buildings at the very bottom center of the photographs are where Peter's Video is today.

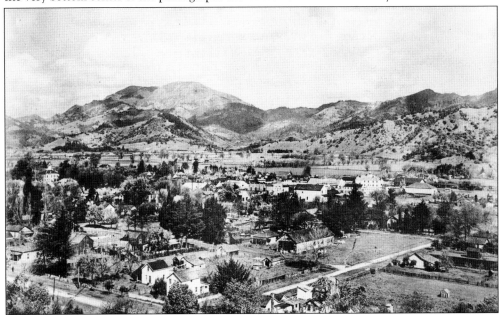

Three

SARAFORNIA DREAMING

Following the creation of that first upper valley neighborhood, the trail that led to the Hot Springs territory became a virtual highway filled with the pioneers of commerce and industry and the craftsmen who supported them. When Brannan's resort opened in 1862, alone and circling tiny Mount Lincoln, it had the neighborhood to itself, but not for long. Brannan and Nathan Coombs in Napa started a daily 24-passenger stage, bringing more folks chasing dreams and starting new lives into town. Two years later came the first general store, located at the corner of Washington Street and Lincoln Avenue—that was also the year Brannan made an error of speech, christening the town with its very unique name: Calistoga.

History hasn't bothered to record many of the details of a dinner party in 1866 when Brannan is said to have named the town. The only significant detail—which has been recalled countless times since with various embellishments—is that after Brannan's lips had been lubricated with the product of his own brandy distillery, he was boasting of his intention to make the Hot Springs territory superior to the famous Saratoga Springs in New York state. Intending to say he would make the territory the Saratoga of California, he instead declared he would make it the "Calistoga of Sarafornia." Almost 20 years later, in 1885, the town's people were celebrating their 135-19 vote in favor of incorporating themselves as the City of Calistoga. Three years later, the state legislature designated it a city of the sixth class.

If the growth over the next few years was put to music, it might have sounded like Beethoven's "Creatures of Prometheus: Finale," a spirited waltz. A water reservoir was built in the hills and a water system installed; the first bridge was built across the river on Lincoln Avenue for $1,915. In 1889, Sam Brannan, who held his world by the tail when naming the town just 24 years earlier, died penniless in San Diego. He never recovered from a divorce filed by his wife, Ann Eliza, in 1870, giving her much of the family's Calistoga property.

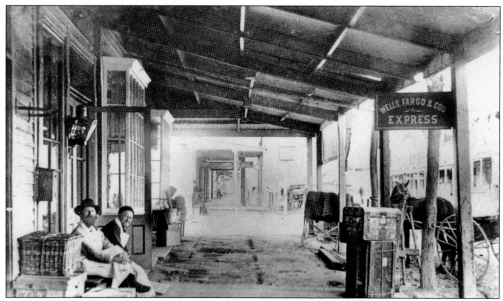

In old Calistoga, longtime neighbors young and old recognized that those who had lived in the community the longest were given names of affection by the younger generations. One example is of a man called Grandpa Wolfe (probably in the apron), who was sitting beside an unidentified friend, relaxing beneath the wooden awning, probably in front of the Calistoga Depot.

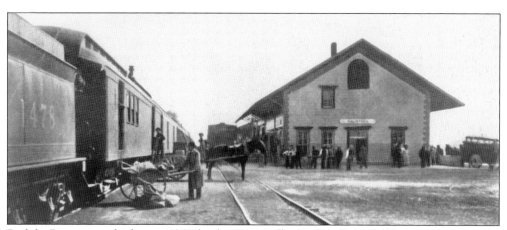

Built by Brannan and others in 1868 for the Napa Valley Railroad, the Calistoga train depot was always a busy place in the early days. Visitors from San Francisco would typically take a ferry to Vallejo Landing in Sonoma County and board the train there. Southern Pacific bought the company in 1885 and added the line to its California Pacific routes. Passenger service to Calistoga ended in 1936, and today the line's only remnant is the Napa Valley Wine Train—a high-end tourist excursion. The Calistoga depot is the second oldest in the state in its original location.

Brown's Blacksmith shop was on Lincoln Avenue next to where the office of the local newspaper, the *Weekly Calistogian*, once stood. Both burned down during the great fire of 1901. Unlike the blacksmith shop, which was never rebuilt, the newspaper rebounded, printing for weeks following the conflagration in the offices of the *St. Helena Star*, 9 miles to the south. In spite of the devastation, the newspaper never missed an issue.

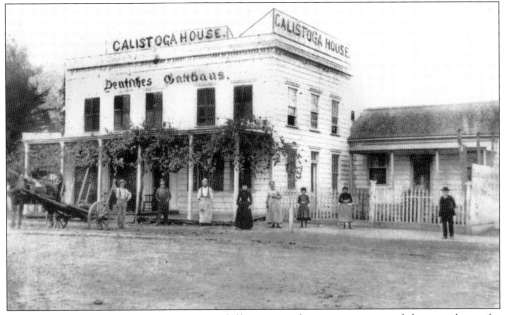

Calistoga has long been home to many different peoples, a microcosm of the populace of a changing America. There were Spanish, Italians, Irish, Chinese, and, as can be noted from this photograph, Germans. This 1890s German guesthouse is located at the corner of Lincoln Avenue and Myrtle Street, where the Garnett Inn stands this day.

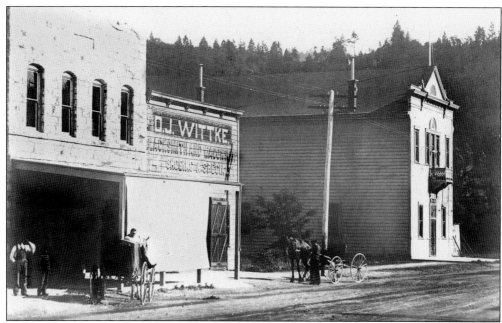

At one point in its history, Calistoga had several blacksmith shops—like this one to the left of the D. J. Witke building. Folks brought their horses to get new shoes or to have a variety of items made for use at home or on the farms. The Masons Lodge building (at the far right) replaced the original lodge, which burned in the 1901 fire. The original structure was built in 1886. Brannan was said to have been a Mason, but his membership in the San Francisco Lodge was suspended for nonpayment of dues.

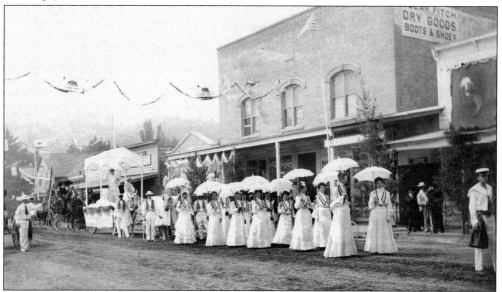

Parades have always given audiences a thrill, and that has been especially true throughout Calistoga's history, whether it was a holiday like the Fourth of July, the dedication of the new library in 1924—attended by more than 400 members of the Napa chapter of the Ku Klux Klan—or this parade of ladies in white in 1890. Another major holiday celebrated annually in Calistoga was Admissions Day, on September 15, a celebration of the day when California entered the Union.

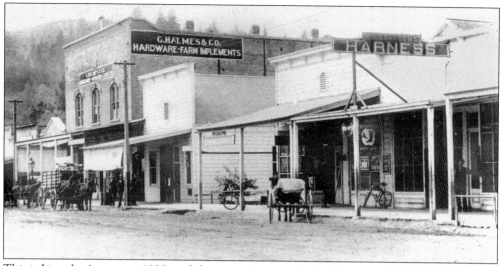

This is Lincoln Avenue in 1898, and the stores shown include Wilson and Sons Harness and G. Halmes and Company Hardware among others. This is the stretch of Lincoln Avenue, looking west toward Foothill Boulevard, which was once called Main Street. The sidewalks here are made of wooden planks.

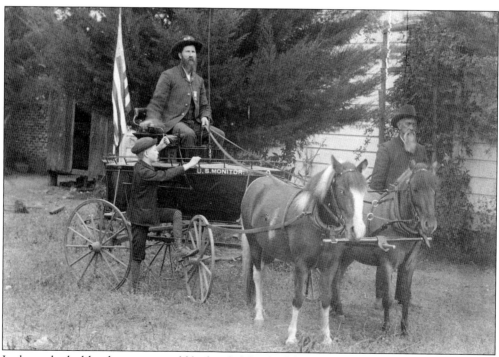

It almost looks like these guys could be headed for the lake. They have what looks like a fishing rod in the carriage with a lure tied on. In this photograph, taken in 1879 or 1880, Newton Conner (in the carriage), his son, and an old gentleman are about to set off in a carriage that is not only shaped like a boat but one christened the name of a famous Civil War vessel. Though they look to be water bound, they are probably headed for a parade.

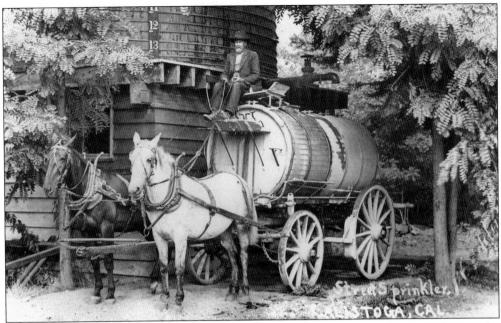

Before Calistoga started paving its streets in 1923, people wore dusters, light jackets, over their regular clothes because the dirt streets could be really dusty. To address the problem, cities and counties hired people like former stagecoach driver Porter Decker, who came to town in 1874, to drive water wagons and sprinkle water on the streets just to keep the dust down. This water tank was next to the upper Napa River bridge where Berry Street and Washington Avenue come together today. Porter had also once managed Harbin Springs Stables before he began driving the sprinkler.

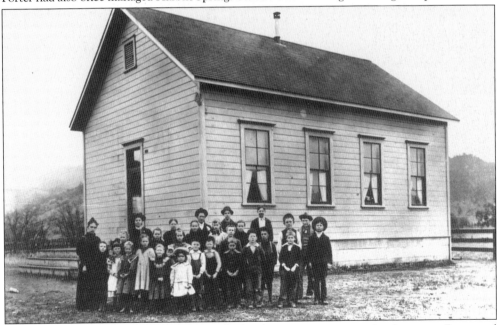

By the end of the 19th century, Calistoga had at least two grammar schools: one at Berry and Cedar Streets where the Calistoga Elementary School is today and another at Bennett Lane just off Tubbs Lane today. This is a class of students at the Bennett School in 1900.

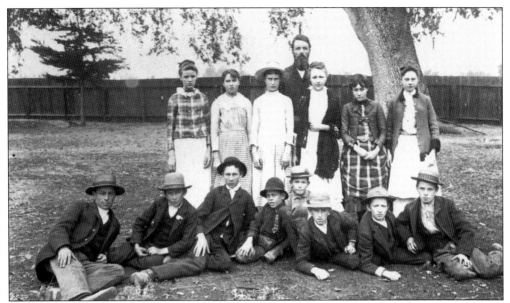

Here is a fine picture of the Calistoga class of 1890. What makes this photograph so sweet is that the boy second from left is I. C. Adams, who would grow up doing a number of jobs before, as a middle-aged man, he was introduced to photography by a friend. He was the man behind the camera for many of the photographs featured in this volume from the 1920s on. Adams, also known as Burt, was born in 1874 on a Native American reservation and came to Calistoga in 1882. In this photograph, he was only 16 years of age. He died August 21, 1960, at 85 years, 11 months, and 19 days. His unmarked grave resides at Section G, Lot 7 in Calistoga's Pioneer Cemetery.

The first crossing built on Calistoga's section of the Napa River was behind the Sharpsteen Museum, at the end of Spring Street where the park is today. A bridge over Lincoln Avenue was next, in 1890, built at a cost of $1,915. This small bridge is the Greenwood Avenue Bridge, north of downtown.

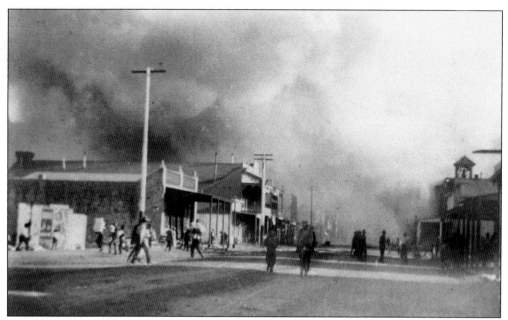

Calistoga was just hitting its stride as a bustling town when, in August 1901, nearly the entire downtown community was burned to the ground. It started just west of the depot behind John Wolfe's Grocery, jumped the street to Spiers Stable (where Bank of America is today), spread to the building where Miguel's Restaurant is in 2008, and then burned everything not made of brick-and-mortar to the Napa River Bridge. Miraculously, no lives were lost in the conflagration. Calistoga has had several fires since but none so devastating.

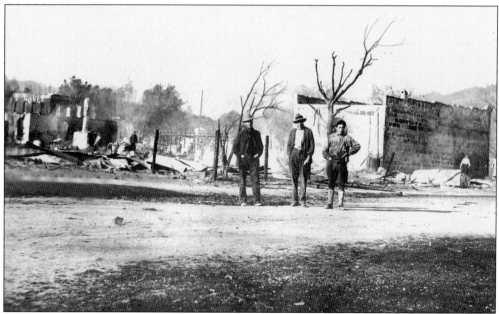

This photograph was taken where Calistoga City Hall is located today. It was once the location where the Badlam's Opera House stood before the 1901 fire. These three men are standing behind the building that is the Hydro Grill today, at Washington and Lincoln Avenue.

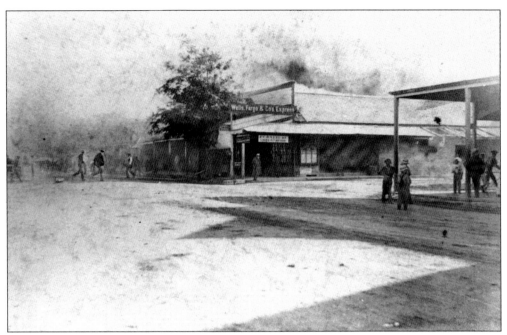

Even as Calistoga was burning, an unknown photographer captured the scene for future generations. This is the Lincoln Avenue and Washington Street corner of town where Bella Tootsie is located in the former national bank building. The awning at the immediate right is in front of the building housing the Hydro Grill in modern times. In 1901, it was the hardware and general store where I. C. Adams was working.

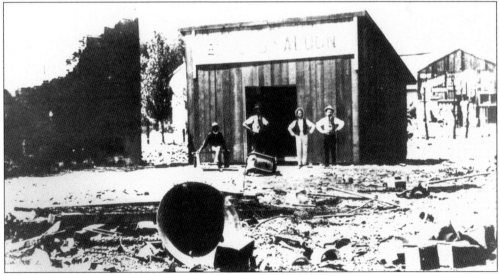

The first building erected in town following the August 3, 1901, fire that destroyed nearly the entire downtown was—what else?—a saloon. Ed Largely and friends resurrected his business in a small single-room shanty directly across Lincoln Avenue from the Calistoga Depot.

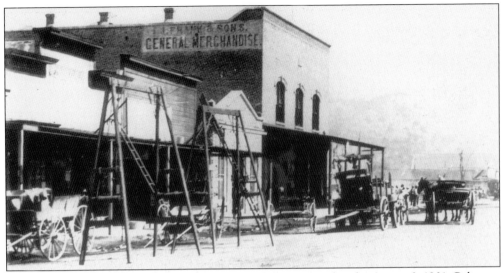

This is a typical scene during the reconstruction of downtown after the August 3, 1901, Calistoga conflagration. The tallest building here is where A Man's Store is located in 2008. It was formerly known as the Oddfellows Building.

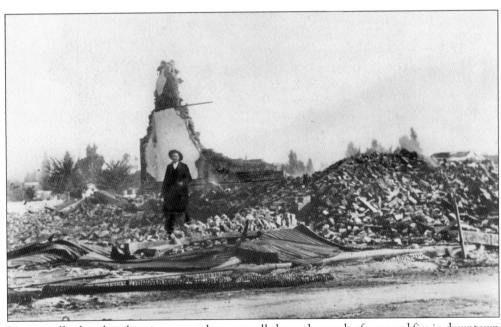

It's not really clear, but this picture may have actually been the result of a second fire in downtown Calistoga in 1918. There have been major fires in Calistoga in 1901, 1907, 1918, and again in 1964.

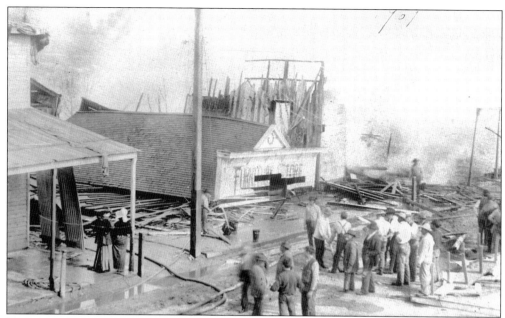

Townspeople survey the smoldering ruins of a furniture store once located near Washington Street and Lincoln Avenue downtown following the August 1901 fire. The fire was able to spread because the town's only fire hose was connected to a hydrant too close to a burning building and it was also consumed.

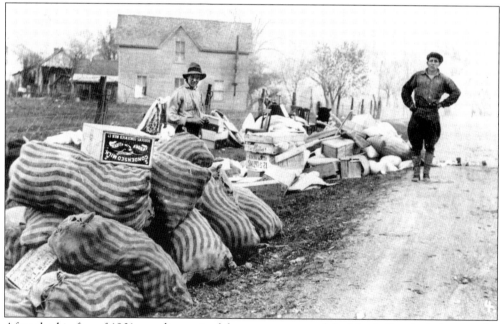

After the big fire of 1901, supplies arrived from many parts of the North Bay, including nearby St. Helena. Calistoga's newspaper, the *Weekly Calistogian*, reported that its facilities had been burned to the ground and that only a few issues were lost. For several following weeks, the paper was published at the facilities of the *St. Helena Star*. Here supplies were donated by people from St. Helena, called by the local newspaper "Calistoga's sister city."

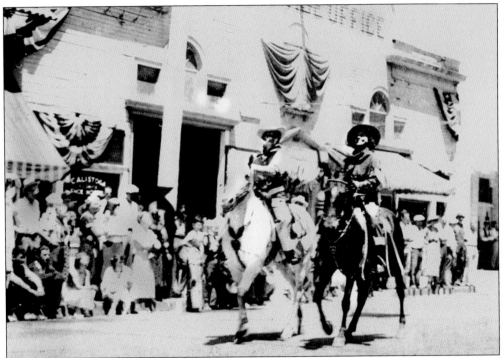

Calistoga has always been a city of people who have overcome adversity. They love their town and said so repeatedly in its many parades, such as this one from before the great fire. This photograph can be dated to prior to the 1901 conflagration because of the building in the back bearing a sign that reads Spiers Stage Office. The original stage office was located where the Bank of America is today, 1429 Lincoln Avenue, and it burned down within 30 minutes of the start of the 1901 fire. It didn't take long for Calistoga life to return to normal.

Before the region was turned into wine country, farmers arriving since the mid-1850s grew lots of other foods: hay for the livestock, plums, walnuts, wheat, and more. They raised chickens, too. It was a busy time, and it wasn't long before Calistoga was back on top of things, with parades and celebrations and progress.

Four

CALISTOGA
CONFLAGRATION

By the end of the 19th century, Calistoga had grown up and most of the early pioneers had vanished, slipping out of time and into the cemetery, leaving the town they carved out of the wilderness to a new generation. Calistoga had become a western town. Its streets crowded with carriages, pedestrians, and people on foot. Dust, whipped by the wind of a noisy, people-laden stage, carried the scent of civilization and was caught mid-air by men and women who hammered the wooden sidewalks with their boots and high, buttoned shoes. Town hall was moved closer to downtown from Railroad Street, Fair Way today, to the corner of Gerard and Washington Streets before moving to Lincoln Avenue where it was in the heart of the city. That is where it burned down.

August 1, 1901—some say it was August 3—was already a hot day in Calistoga, but it got hotter after two drums of gasoline stored in the back of the John Wolfe Grocery store on Lincoln Avenue—near where the Smoke Shop is today—exploded around 5:00 p.m., unleashing the fury of Cerberus, the mythical three-headed guardian of hell, on Calistoga. Local firemen attached a hose to a hydrant in front of the burning building but were pushed back by fire's hot breath, and the town's only fire hose burned where it lay. The blaze continued toward the Napa River Bridge on that side of the avenue and jumped across Lincoln Avenue to Bill Spiers's livery stable. The men were able to get the horses out of the building, which was totally destroyed, as was anything not made of brick and mortar. Heroics were performed by many, including Homer Hurst, who rushed up the burning stairs of city hall to rescue the town's records.

The townsmen erected a saloon not far from where Cal Mart is, at Lincoln Avenue and Fair Way today, after the fire, and the townswomen set about helping those suffering from loss. A similar disaster was averted in a 1907 blaze when the townsmen pulled down a building to keep the fire from spreading. Finally, in 1911, the firemen got a new fire hose cart. Calistoga life quickly rose from the ashes of both fires.

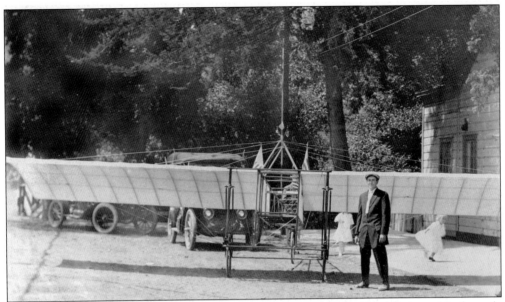

The Wright brothers may have gotten the idea off the ground first, but they weren't the only ones trying to provide mankind with wings. Actually, there were two attempts by locals to build flying machines, and both attempts were made only once. This one, attempted to be flown by an unidentified would-be pilot, was taken to the Light Winery in the early 1900s, sometime before 1905. This pilot thought if conditions were favorable, he could pick up enough speed traveling down the lengthy slope of the roof at the Grant Street winery and glide to the ground. Instead, when he crossed over the edge of the roof, gravity took over. Luckily he escaped with a few cracked bones and scrapes and bruises. He never tried that again.

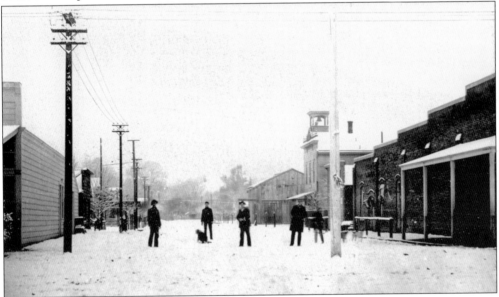

It looks like a snowball fight at high noon. Four men brave the elements at Lincoln Avenue and Washington Street—identifiable by the pole in the middle of the street—during a snowstorm in 1909. The building with the bell on the right is the current city hall. Its location was moved from Lincoln Avenue after the 1901 fire to this location, where it stands today.

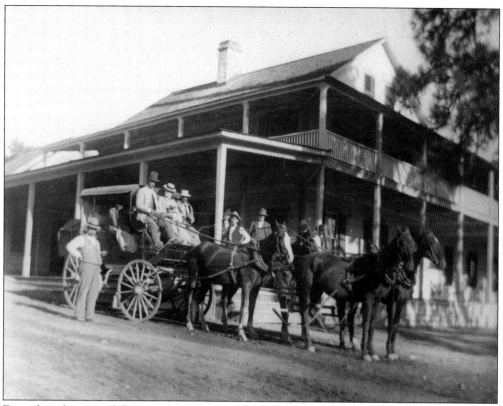

Even though automobiles were beginning to show up occasionally, stages like this one leaving Lake County Resort for Calistoga in 1899 remained popular as late as the 1920s.

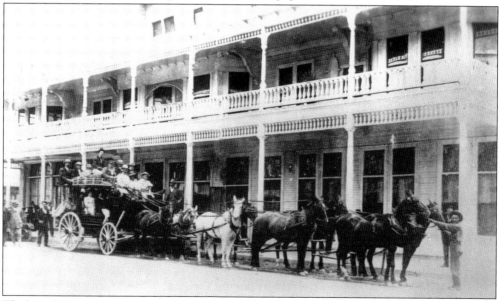

The horseless carriage, or automobile, was around, and a fender of one can be seen at the extreme left. But even in the early 20th century, the stage was the preferred method of travel out of town. In just a few years, cars would begin to crowd teams like these from the roadways.

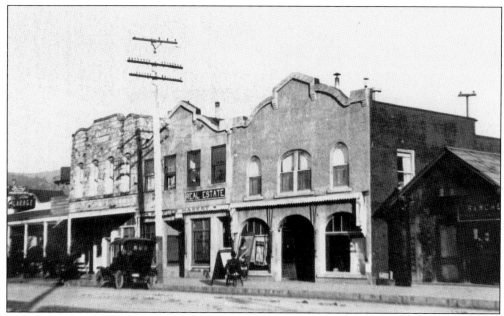

Another view of Lincoln Avenue shows the real estate office of Judge M. E. Billings and, perhaps, an artist sitting out front. These buildings, at the start of the 21st century, are filled with several different shops, including an art studio and a bicycle shop; the real estate office and garage at the far left have long disappeared from this early-1920s scene.

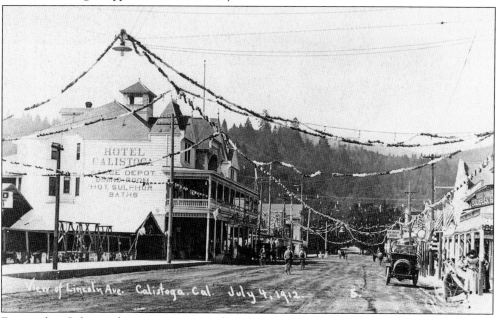

Even today, Calistoga loves getting gussied up for a parade, although it doesn't go as far as its great-grandfathers did. It seems the favorites have been Fourth of July parades and Admission Day, on September 15, celebrating the anniversary of the date California was admitted to the union of the United States of America. It was typical, in the old days, for Calistoga to completely don Lincoln Avenue with red, white, and blue garlands along with copious American flags, as seen in the July 4, 1912, photograph.

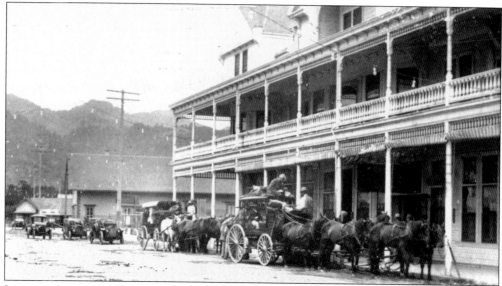

It seems almost unbelievable today that as late as the 1920s and early 1930s, people took the stage to and from Lake County and communities on the other side of Mount St. Helena. These stagecoaches, ahead of a small caravan of cars, have just rolled into town, making the usual stop at the Hotel Calistoga where Bill Spiers had a ticket office. The long building in the background is Calistoga's historic train depot. Notice the lights hanging above the street.

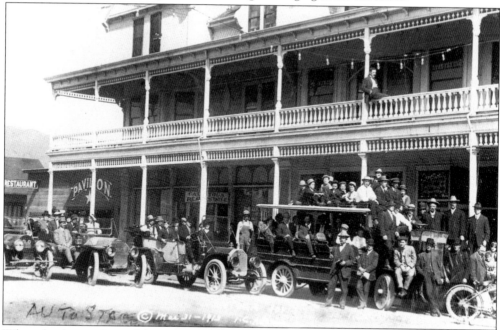

When the day was beautiful, as it is most days in Calistoga and was on March 31, 1913, it wasn't unusual to see what seemed like the whole town turn out for a drive up Mount St. Helena and beyond to visit the Lake County resorts. Riders could pick up the auto caravan to travel up the sometimes-rutty one-lane dirt road. Once leaving the Hotel Calistoga, they would run onto Washington Street, then again right onto Lake Street, which was then called Lake County Road, then onto Highway 29 (as it is known today) for the excursion north.

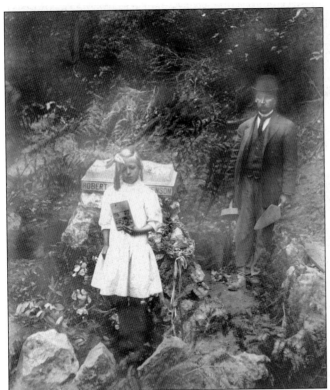

A young girl is part of a dedication ceremony to a monument to Robert Louis Stevenson up on Mount St. Helena on May 7, 1911. Unfortunately, the young miss was not identified, nor was the craftsman waiting with trowel in hand for the girl to finish.

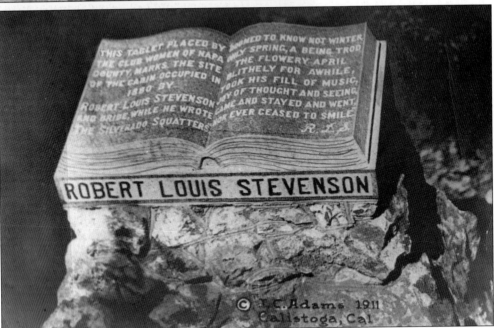

Here is the tablet placed by the clubwomen of Napa County. It marks the site of the cabin occupied in 1880 by Robert Louis Stevenson and his bride while he wrote *The Silverado Squatters*. The marker contains a verse allegedly penned by the writer, who filled a small volume with delightful profiles of the people of Calistoga.

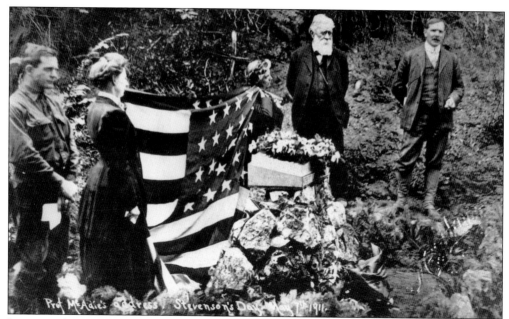

It was on the morning of May 7, 1911, that a group of women's club members from all over the Napa Valley, and some of their families, made their way up Mount St. Helena to dedicate a monument to one of the earliest great writers to visit Calistoga and the region: Robert Louis Stevenson. While the women hold the flag, one Professor McAdie delivers a narrative in honor of the self-proclaimed Silverado Squatter.

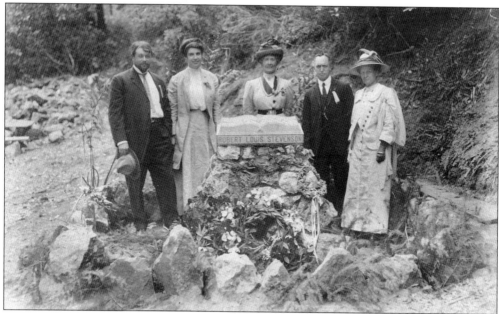

Several Calistoga residents made the trip to Mount St. Helena to dedicate a monument to Robert Louis Stevenson on May 7, 1911, a minor holiday known at the time as Stevenson's Day. The identities of the pair on the left were not noted; the others were, from left to right, Mrs. Agnes Fisher (wife of William Fisher), Mr. Charles Armstrong, and Mrs. Alice Fisher Armstrong. Charles Armstrong was Calistoga's pharmacist for many years.

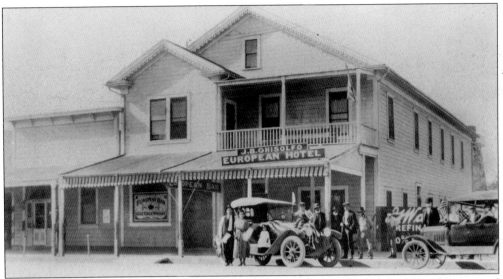

John Ghisolfo's European Hotel was the forerunner of today's Mount View Hotel. Riding around in an open vehicle could stir quite a cloud of dust. Looking very closely at this photograph, taken around 1912, all but three people standing near the motorcars are wearing dusk masks. This was also the year the Calistoga School District was established—with only eight students. By the end of the year, 30 more students had joined the local school system.

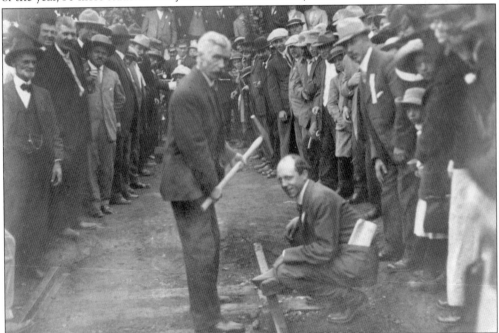

In 1982, the Sharpsteen Museum received a letter from a man named Donald Rutherford Newsom, of Sutter Creek, California—and this photograph of his father, John Rutherford, a former mayor of Calistoga, about to drive the final spike on the then-new electric railroad, operated by the San Francisco, Napa, and Calistoga Railroad, on September 2, 1912. Rutherford, who lived next to the old Armstrong house on Foothill Boulevard, was mayor of Calistoga for 10–15 years at the start of the 20th century.

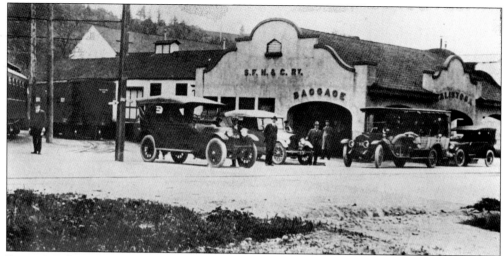

From 1912 through February 13, 1938, people could ride from San Francisco on a ferry to Vallejo before catching the electric train from Vallejo all the way into downtown Calistoga, where they could catch a waiting taxi or an auto coach and continue on to places like Fossville, Knight Valley, or the Lake County resort on the other side of Mount St. Helena. Today a short length of the original track and a monument dedicated by the Native Sons of the Golden West are all that mark this great old depot. The immediate foreground in this picture is now the paved parking lot for West America Bank.

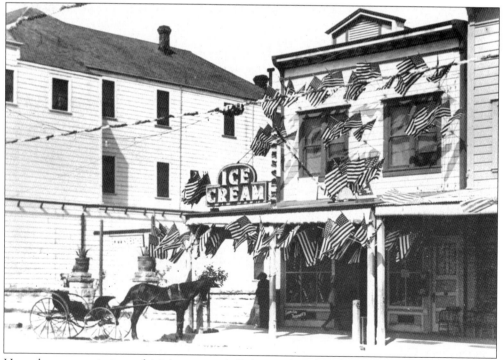

How about a patriotic parfait? As reported, Calistoga loved to decorate for the Fourth of July holiday. Peter Hopkins Jr., who owned several businesses around town, did a particularly fine job of decking out his ice cream parlor on July 4, 1912. The location of this building was between the Hotel Calistoga and Washington Street.

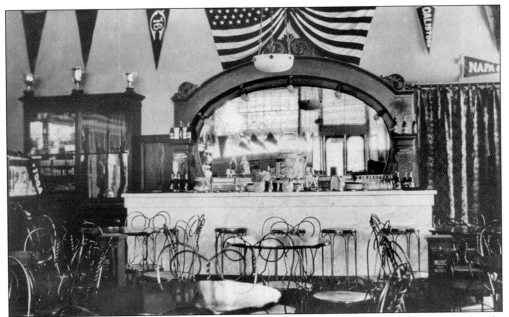

This is the interior of Peter Hopkins Jr.'s candy, soda fountain, and ice cream parlor on Lincoln Avenue. Just months after this picture was taken, the final spike in the town electric railroad track was driven. This building is where Brannan's Grill is located in Calistoga in 2008.

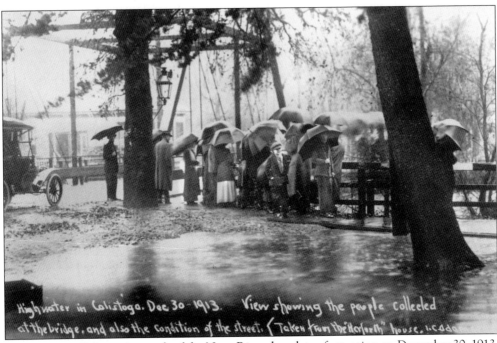

High water in Calistoga's stretch of the Napa River drew lots of attention on December 30, 1913. People gathered at the bridge to see the high water splash the bottom of the bridge. This image, taken from the Herforth property, not far from where the Bank of the West is today, shows the ghostly image of the Calistoga Inn in the background.

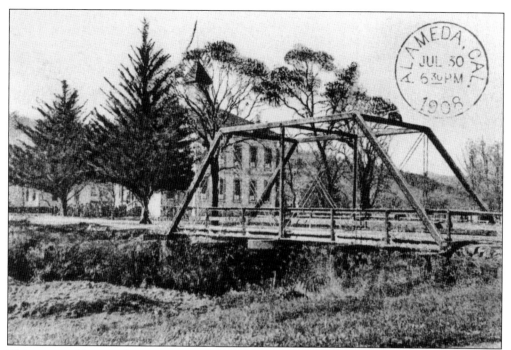

This postcard bears a fantastic view of the old Calistoga Grammar School on Berry Street just after 1900. Today a single-story school stands in its place and the Napa River can no longer be seen from this angle, which is from the position where a small city park sits in the 21st century.

The date was August 26, 1917, and for the second time in a week, a man who went unnamed by the local newspaper walked across Lincoln Avenue on a tightrope. The paper, the *Weekly Calistogian* (before the paper changed its name to the *Weekly Calistogan*), said he created quite a spectacle and that he planned to do it again the next Saturday, but it didn't mention who he was or why he did it.

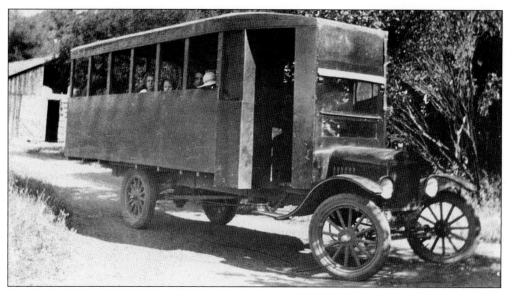

Here is one for the young ones. Today kids board a big yellow bus to head to school, but around 1916, their great-grandparents went to school in big, awkward-looking busses like this one that made the rounds to area farms to pick up students after the school district formed in 1912 with just eight students. Of course, enrollment picked up, and by the end of the first year, there were 38 students.

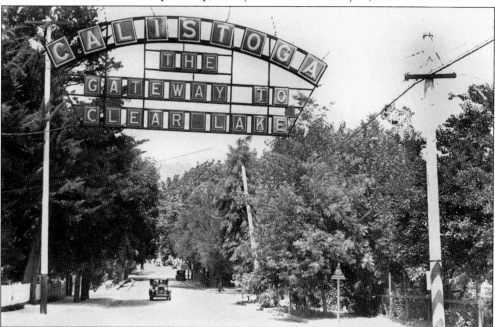

With regular stagecoaches and car caravans to Lake County resorts a part of Calistoga's past, it may come as a surprise that in the 1920s and 1930s, Calistoga still advertised that it was the gateway to Lake County and Clearlake. A sign above Lincoln Avenue a half-block west from the corner of Myrtle Street and Lincoln Avenue once proclaimed that great getaway, and at 15 miles per hour through town and a whopping 30 miles per hour on the highway past Calistoga, it might have taken some two hours to get there. Today the trip, depending on traffic, can be made well under an hour.

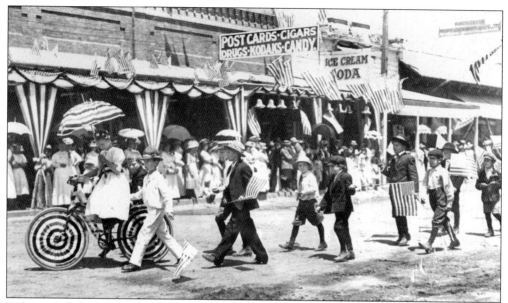

Calistoga's kids showed their patriotic streak during peacetime, marching or riding colorfully decorated bicycles along Lincoln Avenue during their annual parade on July 4, 1911. Notice the patriotic bunting that covers nearly the entire Lincoln Avenue.

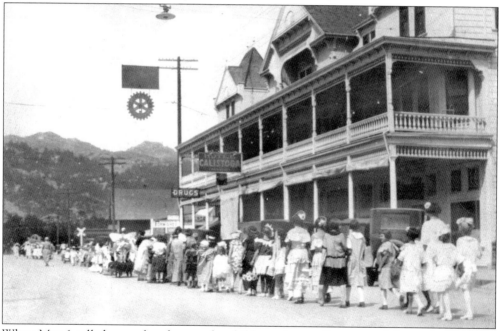

When May 1 rolled around each year, the children of an earlier era in Calistoga history were herded into formation by various women associated with the Calistoga Civic Club or the grammar school, and sometimes both, for a May Day celebration. The events were held in the second decade of the 20th century and into the 1920s. The easily recognizable Rotary International sign hanging above the street as the kids troop down Lincoln Avenue past the Hotel Calistoga dates this photograph to the mid-1920s. Calistoga's Rotary International Club was chartered in Calistoga in 1924.

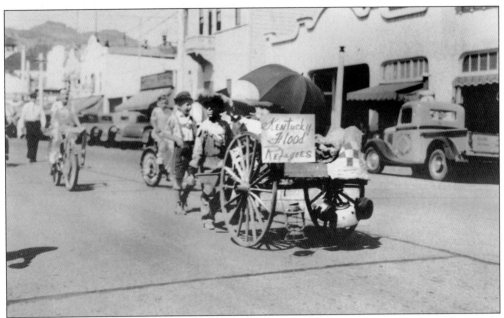

The participants in this undated photograph of a parade seem to mark the struggles of the people of Kentucky. In late January and February 1937, a month of heavy rain throughout the Ohio River Valley prompted what became remembered as the "Great Flood of '37." The flood submerged about 70 percent of the city and forced the evacuation of 175,000 residents. In Louisville, 90 people died. At the crest on January 27, 1937, the waters reached 30 feet above flood level in Louisville.

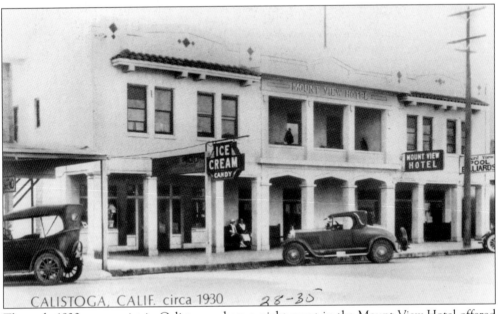

The early 1930s were quiet in Calistoga, where a night spent in the Mount View Hotel offered an opportunity to visit a nearby ice cream parlor or take in a game of billiards in the hotel's own pool room, as advertised in this old postcard.

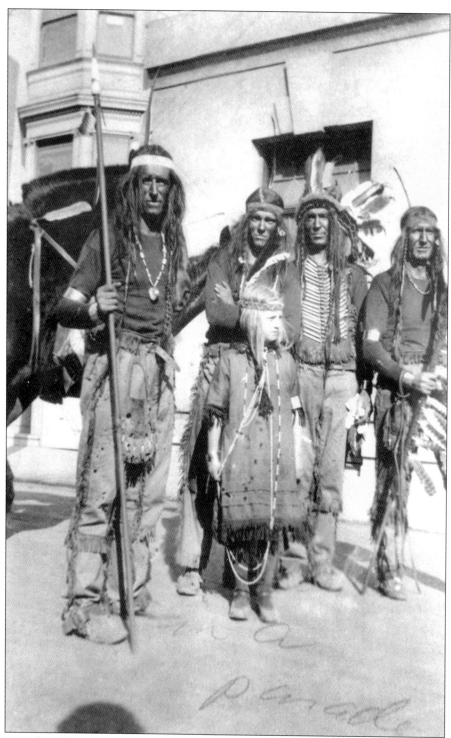

Even as early residents of Calistoga were proud of their own heritage, they sometimes paid homage to the region's Native American tribe, the Wappo, who occupied the region for perhaps thousands of years before American pioneers began to show up in Calistoga.

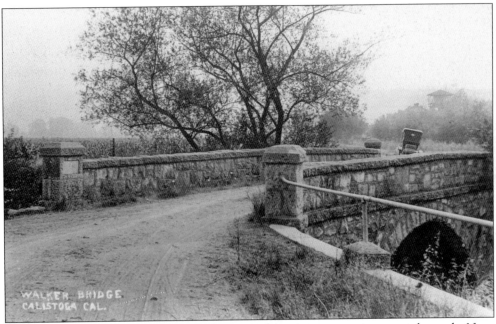

This is the Walker Bridge, which allows Greenwood Avenue to run uninterrupted over the Napa Creek. Its peculiar configuration on a curve has claimed the showroom beauty of many a vehicle. In the future, the city government plans to connect this rural drive to the downtown district with a bike and hiking trail.

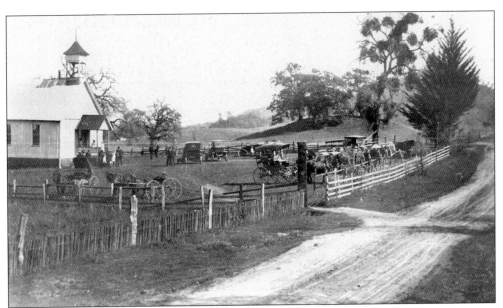

As the pioneer days drifted deeper into the past, it was evident that a rural community was coming together in scenes like this, a typical Sunday near Mount Lincoln on Calistoga's east end of town in the early 1900s. By this time, cars were around, although very scarce. A local newspaper report in 1919 noted that as many as 300 cars existed in all of Napa County, with about 40 in Calistoga.

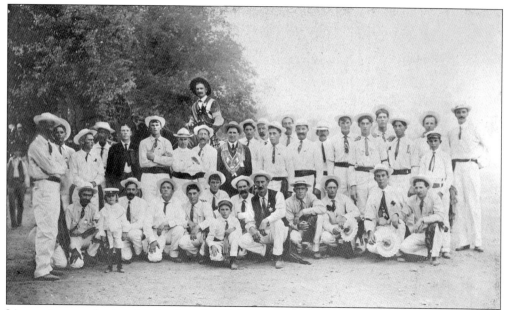

It's nearing parade time for the Fourth of July in the early 1910s in Calistoga, so this group of members of the Native Sons of the Golden West is ready to march. It was not recorded if these are members of the Calistoga Parlor 145 or a visiting group from San Francisco.

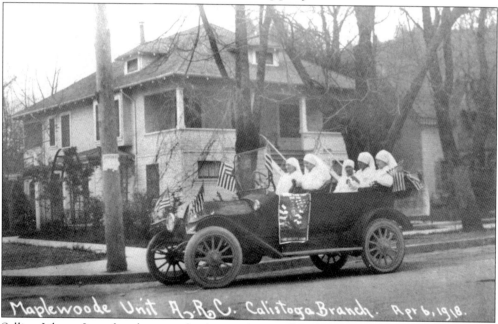

Maplewoode Unit A.R.C. Calistoga Branch. Apr 6, 1918.

Selling Liberty Loan bonds to pay for America's war effort during the "War to End All Wars," as World War I was called, was an important mission in Calistoga in 1918 for members of the American Red Cross. This photograph was part of series given the author by Arizona resident Susan Nelson, who found the photographs among the belongings left behind by her mother, Thrya Alving Wallace, who grew up near Calistoga, along the Silverado Trail near what is today the Saviez vineyard. Wallace passed away in 2006. The ladies here are volunteer members of the Calistoga Branch of the Maplewood Chapter of the American Red Cross.

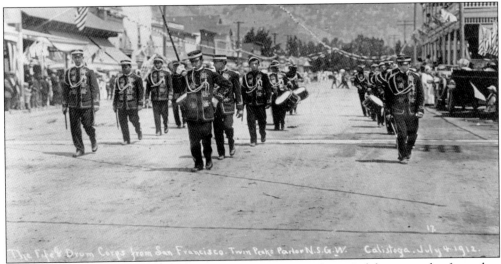

The Fife & Drum Corps from San Francisco. Twin Peaks Parlor N.S.G.W. Calistoga, July 4 1912.

The Native Sons of the Golden West is a group of native-born Californians who formed to preserve California's history for future generations to enjoy. They perform public service by donating monuments to historic sites and providing scholarships to youth, and they travel to support each other at events. On the Fourth of July 1912, this fife and drum corps of the Twin Peaks Native Sons of the Golden West drove to Calistoga for such an event. Calistoga's Native Sons also built floats of their own celebrating the history of California and often appeared in local celebrations and parades.

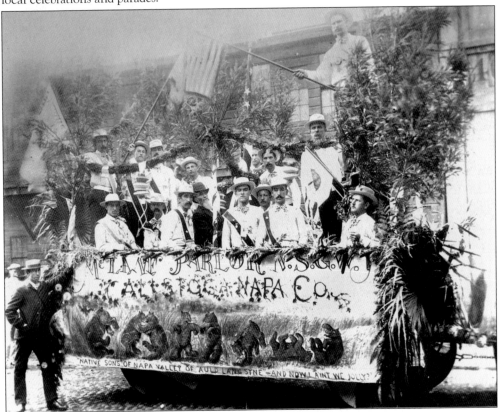

Don't look now, but is that W. C. Fields on Lincoln Avenue in the 1920s? It's just a pint-sized replica, part of a Calistoga children's costume parade where it looks like the children were dressed up as their favorite characters from the silver screen. The little boy appears to be dressed like the former vaudeville actor W. C. Fields, whose most famous line was, "Go away kid, you bother me."

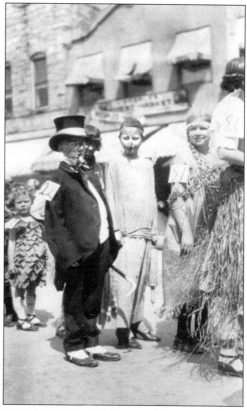

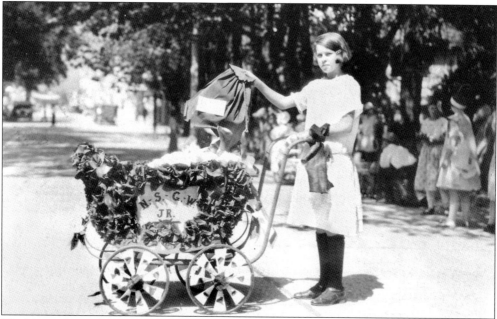

The Native Sons of the Golden West celebrated the state's young people in this children's parade sometime around 1919. As this picture illustrates, the group was interested in recruiting youth into its group, which is dedicated to preserving the history of the Golden State.

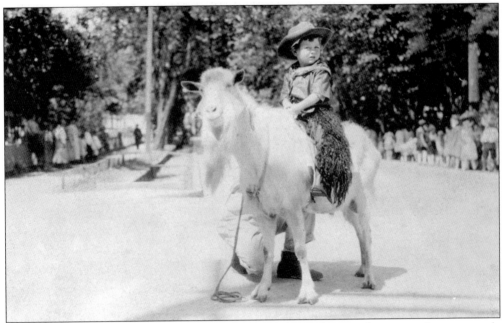

It's the goat-riding cowboy from Calistoga. In this undated photograph, a young boy gets ready to ride down the street in what was one of several children and pet parades held in Calistoga in the second decade of the 20th century.

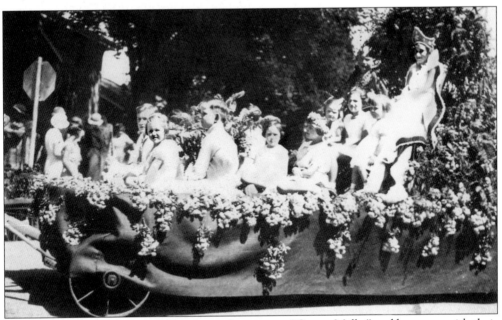

In one of the more elaborate children's parades, a young "Queen Melba" and her court with their escorts ride in the May 1, 1919, parade for a daylong celebration of the coming of spring. The queen, who was chosen by the women of the Calistoga Civic Club, had three princesses, and they in turn each had an escort. There were three young boys to carry the queen's train, a pair of flower girls, and even a band.

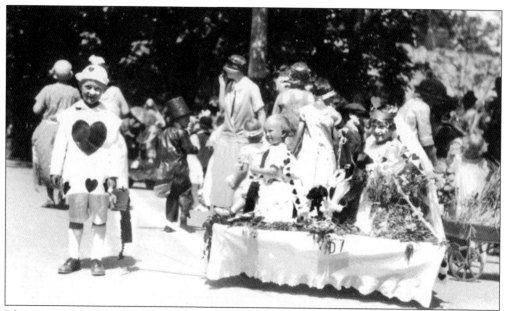

There was a time in Calistoga when the local chamber of commerce had a slogan that fairly boasted that one of the reasons to live in Calistoga was because of its many happy children. It certainly seems to be the case with this undated photograph of a boy dressed as a page of hearts in one of many children's parades hosted by various clubs over a period of about two decades early in the 20th century.

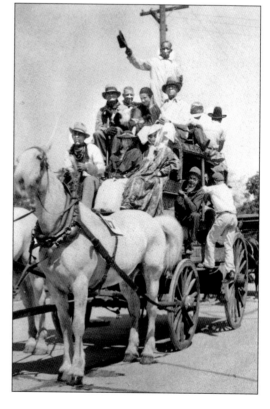

To be sure, Calistoga's children weren't the only ones who loved to shine for a parade. This photograph shows a crop of riders anxious to be a part of a parade feature sponsored by the Native Sons of the Golden West. The serious-looking fellow sitting on the top row at the right is Charles A. Carroll, the editor of the *Weekly Calistogan*. After buying the paper in 1895, he was its editor until 1943.

Founded in 1905 in Calistoga, Parlor 145 of the Native Daughters of the Golden West, the sister group to the Native Sons, was a regular in the many local parades. This photograph was left undated, but a look at the vehicles seems to indicate this parade is one of the more recent, perhaps from the late 1930s or early 1940s.

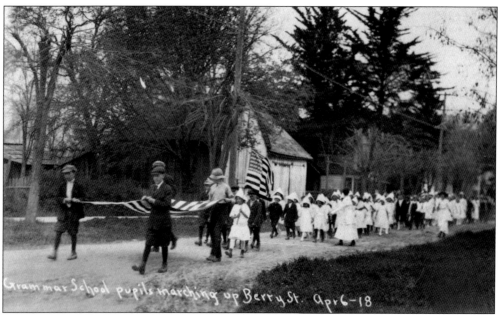

Grammar School pupils marching up Berry St. Apr 6-18

The amazing thing about this photograph is not that the grammar school students are marching up Berry Street on April 16, 1919, heading for a patriotic parade to appeal to the town to help support the troops during World War I, it's the actual size of the street. One of the busier streets in Calistoga today, it was barely wide enough for a single lane of vehicles in the second decade of the 21st century.

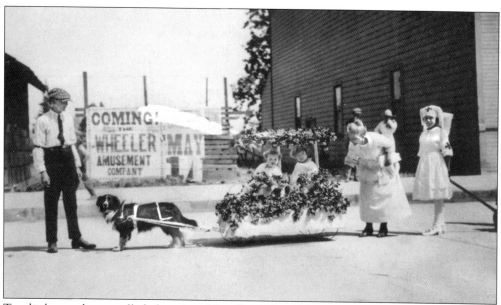

Two little people get pulled along in a May 17, 1919, Calistoga Children's Carnival, another of the many parades built on the happiness of the local kids.

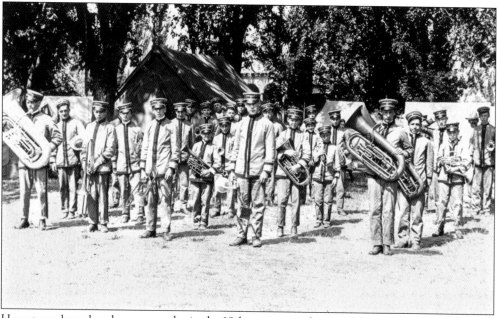

Hometown brass bands were popular in the 19th century, and it seemed especially so in Calistoga. There were big marching bands and small ones, school bands, and church bands. They played at funerals, barbecue events, and the local fair. Although the traditional community brass band was pretty much a thing of the past by 1917, their legacies remain in photographs like this one, taken at the campground where the Napa County Fairgrounds are today.

Two young girls are all dressed up in this undated picture from Calistoga's Sharpsteen Museum. Almost certainly getting ready to participate in one of the era's children's parades, orchestrated by the Calistoga Civic Club, they look to be the epitome of 1920s and 1930s fashion in Calistoga.

A rare sight indeed is this unsettling image of a Calistoga parade. It is undated, and some old-timers have suggested that the photograph was taken during one of Calistoga's "ugly parades." The Ugly Parade was once described as a Calistoga version of Pasadena's famous "Doo-Da" parade, but the son of Al Triglia, one of the organizers, said the intent was to compliment the spirit of the New Orleans Mardi Gras festival. This is the only known photograph of the parades, which were held from the late 1940s to about the early 1960s.

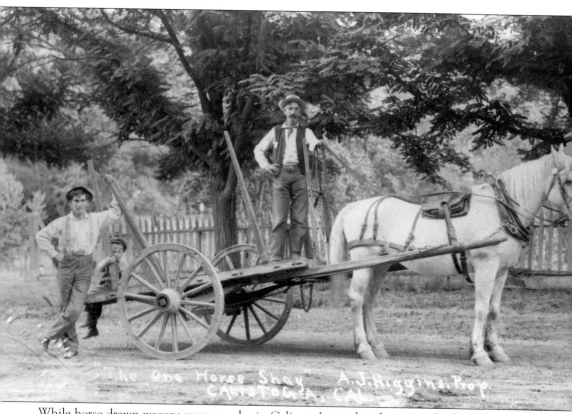

"The One Horse Shay" A. J. Higgins, Prop.
CALISTOGA, CAL

While horse-drawn wagons were popular in Calistoga's parades, they were absolutely necessary for everyday transportation and delivery needs. In early Calistoga, A. J. Higgins was an express man for a great many years. He had contracts with the government and Wells Fargo and carried materials from the post office to the train. His one-horse open shay here was a familiar sight around Calistoga.

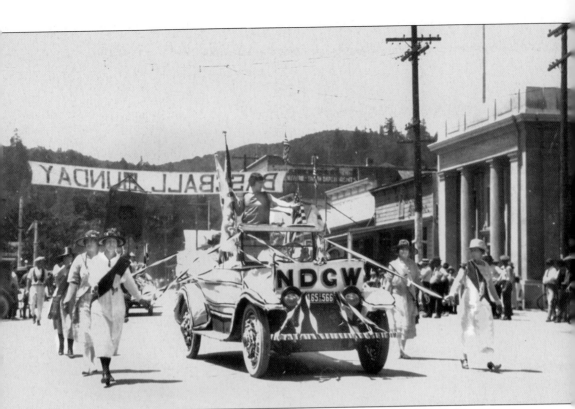

Since they were founded locally in 1905, Calistoga's Native Daughters of the Golden West have erected bronze plaques to assure that Calistoga's history is never far from the public view. One of the most impressive of their projects was to have every issue of Calistoga's newspaper, the *Weekly Calistogan*, transferred to microfilm and available for all to read at the Calistoga Library.

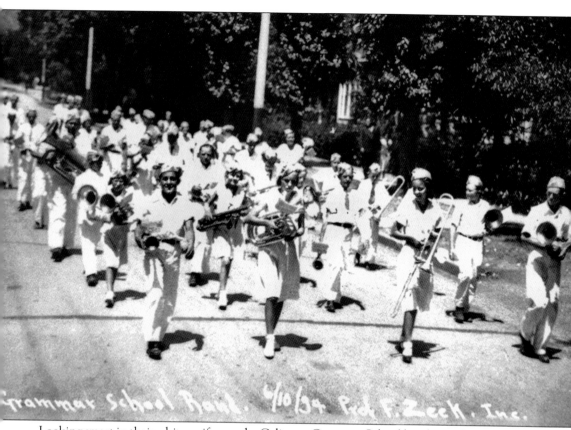

Looking smart in their white uniforms, the Calistoga Grammar School band is ready to entertain the town on some special occasion held June 10, 1934. Their band teacher was Prof. F. Zeek.

Hunkered low between the two horses in this four-horse team, the driver of the California float in this July 4, 1911, parade entry can barely be seen as the team makes its way toward the annual Independence Day celebration.

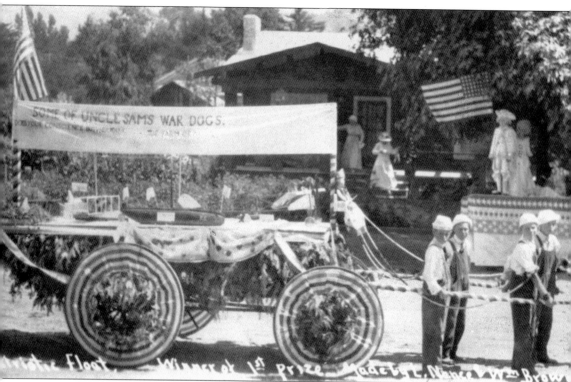

Winning first prize for patriot floats, the Uncle Sam War Dogs float was created by L. Nance and William Brown. The banner appealed to the patriotic conscience of those who had not purchased Liberty bonds to help support the war. The photograph is undated, but judging by the boy in the background dressed in 18th-century period attire, it is likely a Fourth of July parade.

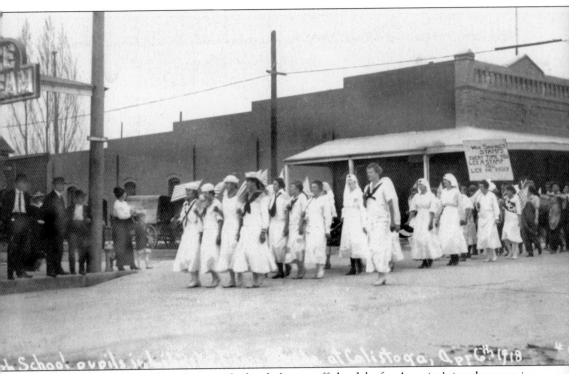

Calistoga's High School students worked to help pay off the debt for America's involvement in World War I by staging a Liberty Bond Parade on April 6, 1918. The sign showed the attitude of the community at the time. It read, "War savings stamps—every time you lick a stamp you lick the Kaiser."

"lower Girls", Children's parade, Calistoga, Cal. May 1st 1920 "6

The day Queen Melba got her crown—May 1, 1920—she was escorted by a bunch of kids, train bearers, and these two flower girls, whom the local newspaper recorded as being the girls of the Lewis and Lee families.

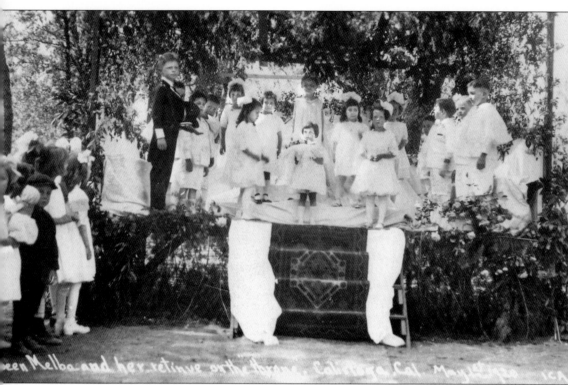

These kids beat Queen Melba to the stage. This retinue of youngsters from the Calistoga Grammar School is awaiting the arrival of Queen Melba, the May 1, 1920, May Day queen. The kids all sang for the group, which spent the afternoon eating ice cream and drinking lemonade with their families. Queen Melba was recognized by the mayor of the town that day and given a key to the city of Calistoga.

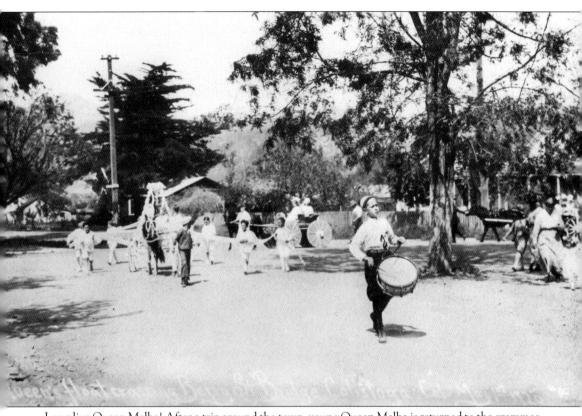

Long live Queen Melba! After a trip around the town, young Queen Melba is returned to the grammar school, where she will be given a key to the city. She will also have some refreshment before being entertained by her fellow students in song and dance, including the traditional maypole dance.

In the final two photographs of children all gussied up for a local parade, the two little girls above, with their dolls, had their pictures taken before one of the social events of the seasons for Calistoga's kids, the Doll Parade, which wasn't necessarily restricted to dolls but could also include some pets. The kids below are dressed up in party clothes for one of the children's parades on Cedar Street in front of Pioneer Park.

Five

A New Hometown

Calistoga had been tried by fire. Twice sons and daughters of the pioneers had beaten back the flames of adversity, and the town was thriving. Calistoga had abandoned its coal oil-burning streetlamps for 400 electric lights and 24-hour electric service from Calistoga Electric Company—and lamplighter Homer Hurst, who saved the city records during the 1901 fire, was out of a job. A new city hall was built over a spot once home to the Badlam's Opera House. Electric train service was coming to Calistoga. The Calistoga High School District was established with just eight students, but by the end of that first school year in 1912, thirty-eight had enrolled. Calistoga built its first jail for $385 and purchased its water system from the builder, W. F. Fisher, for $40,000. It also started building its sewer system. With the growing popularity of automobiles, streets were paved.

Calistoga's social framework grew, too. A pair of men had built flying machines. One attempted to launch from the roof of the Ephraim Light winery building on Grant Street. Another tried to launch by rolling down Mount Lincoln. Both failed, and neither ever tried their stunts again. Another man, on at least three occasions, walked on a tightrope above Lincoln Avenue while hundreds of townspeople held their collective breath below.

The Calistoga Civic Club had formed. They focused on the genteel aspects of community. They hosted children's parades and built a clubhouse, half of which they dedicated as a library for the community. When a parade was held to celebrate the library's opening, a couple hundred members of the Knights of the Ku Klux Klan and their families showed up from Napa to help celebrate. Students formed patriotic groups to boost support of America's participation in World War I. Men formed the Calistoga Boy Scouts and the Calistoga Rotary International Club.

Calistoga was in its glory days, but the automobile would cost the city its train service while making its streets busier than ever as more people came to visit the popular "Waters Coming Up Village."

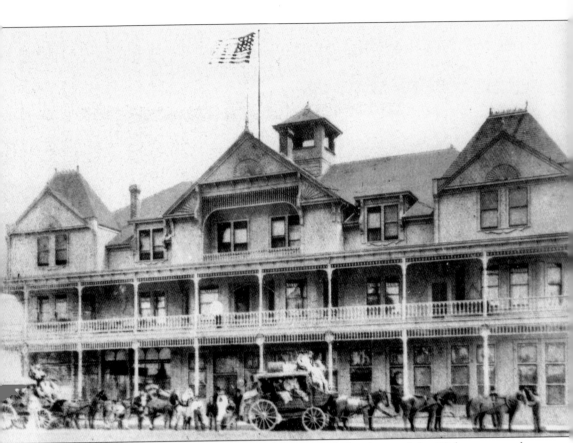

Although there were many hotels in Calistoga around the dawn of the 20th century, the Hotel Calistoga seemed to get more than its share of attention. It was easily the largest hotel in the community and also served as a kind of travel center, where coaches drove south to Napa City, north to Lake County, or west to Healdsburg, Fossville, Geyserville, and beyond. Finally, as the 1920 and 1930s rolled around, it began to see more customers coming in by car or the new autobuses.

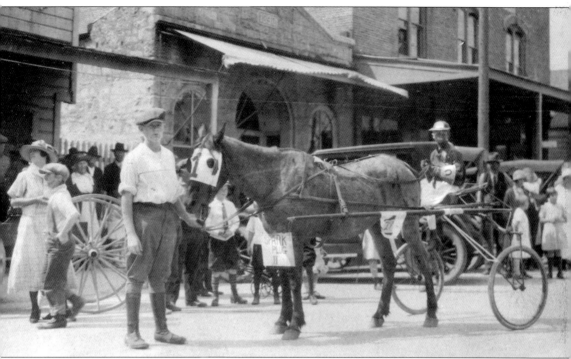

Even though they were getting ready for a parade in this photograph from the early 1930s, the streets were becoming crowded as the horseless carriages jostled to use the same roadways. With the coming of the automobile, some people were able to have a sense of humor about the changes. Take for instance the sign hanging on the front of this horse: "spark plug number two," it reads.

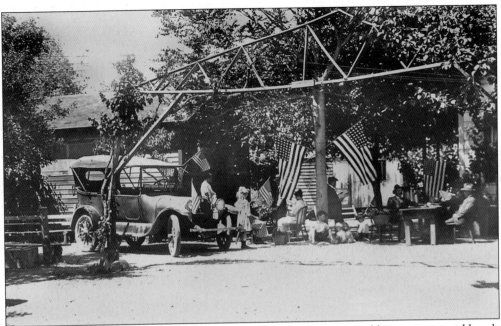

Another change with the coming of the auto is that more families could visit resorts and hotels away from the Calistoga downtown, like this spot at the Shady Resort, which was located next to Cyrus Creek, the small stream that runs parallel to the Petrified Forest Road when traveling to Calistoga from Santa Rosa today.

Where Calistoga used to have several blacksmith shops where travelers and express men could get their horses shod or parts for their wagons and carriages, Calistoga started to grow more service stations, like this Union gas station once located near the corner of Foothill Boulevard and Lincoln Avenue. The station was named after the geysers, a natural wonder still popular with visitors today.

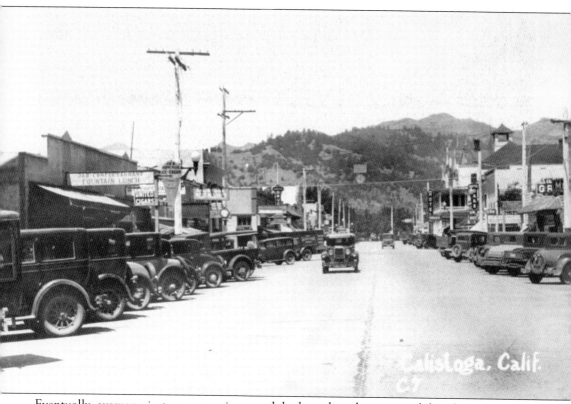

Eventually, everyone in town, or so it seemed, had purchased an automobile, which prompted the city to remove the flagpole that stood in the center of the Lincoln Avenue and Washington Street intersection for many decades.

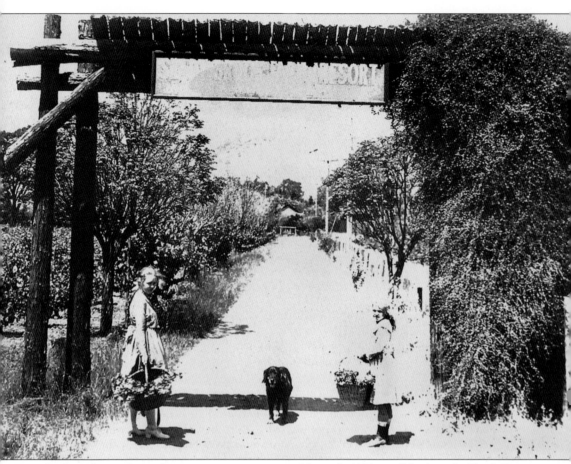

Back on the outskirts of town, two young women of the early 1930s stroll back to the Shady Resort, which exists no longer. With its campground-style bungalows and easy access by automobile, it was a popular spot for the weekend visitor to Calistoga.

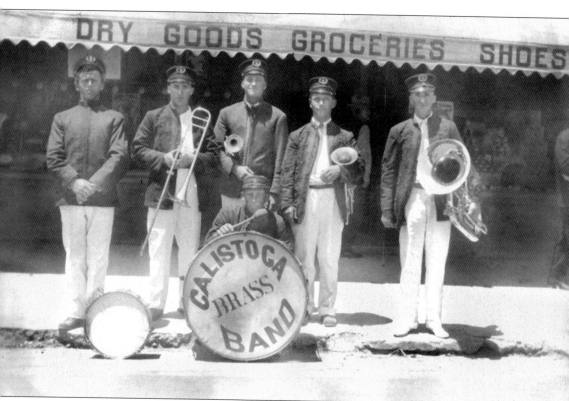

In Calistoga, every era through the 1920s or so came with its official brass band, but the band in this undated photograph may have performed even later, since its recorded members would have been quite young in the 1920s. Although there are six gentlemen here, only the names of four were available from the Sharpsteen Museum archives. They are, in no certain order, Bill Kortum, Jessie Manuel, Charles Rockstoh, and Henry Otto. This band may have performed as late as the 1930s.

It wasn't necessary to attend all the parties in town to learn that early Calistogans loved to have fun—it's part of the town's resort legacy. A good example is this photograph of a Mrs. W. L. Blodgett, the wife of a local doctor, paying off a political debt she owed to this famous old-timer—Bill Spiers. Bill Spiers used to run the biggest stagecoach line around these parts, but once cars started rolling around town, he switched to using autobuses. This photograph was taken in the early 1920s. The nature of the political bet remains a mystery.

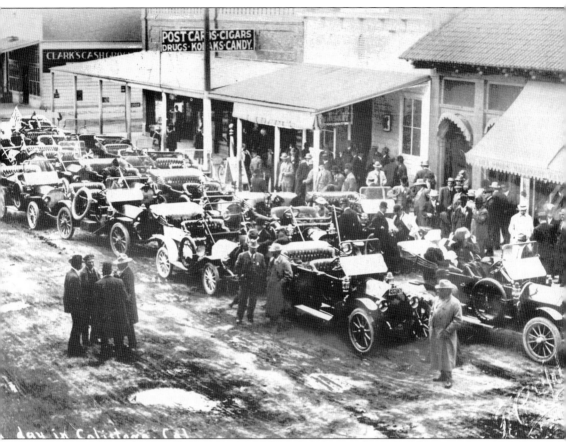

In another undated photograph, a convention of auto owners must have found a common reason to come to Calistoga in the early 1920s, but whatever the reason, their arrival made for a busy day for traffic in Calistoga. All of these automobiles are parked beside Lincoln Avenue outside of what is today the Hydro Grill and the Café Sarafornia.

The Shady Brook Resort and Farm just northwest of town offered visitors with and without new cars a quiet place to relax. With cabin-style tent cabins and hot water, it was what some called a poor man's resort with a so-called heyday that ran mostly during the second and third decades of the last century. The resort was especially popular during the Great Depression. Local blacksmith-turned-mechanic Jacob Lerner, who used to make drill bits for the local miners, created the resort. Its property has since been divided and sold.

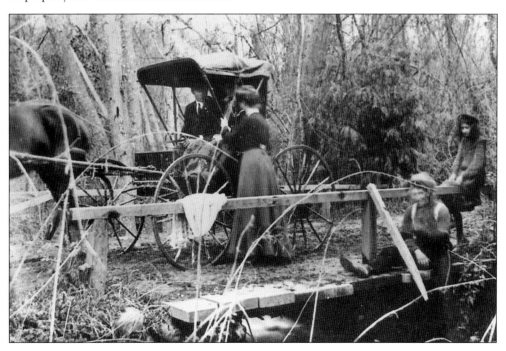

What was left of Sam Brannan's goldfish pond was a favorite place to go at the Brannan resort next to Mount Lincoln. Water to the pond came from a reservoir at the top of the hill. The pond was bordered by petrified wood pieces hauled from the Petrified Forest some 5 miles east of town. The pond was located inside the grounds of what is today the Indian Springs Resort.

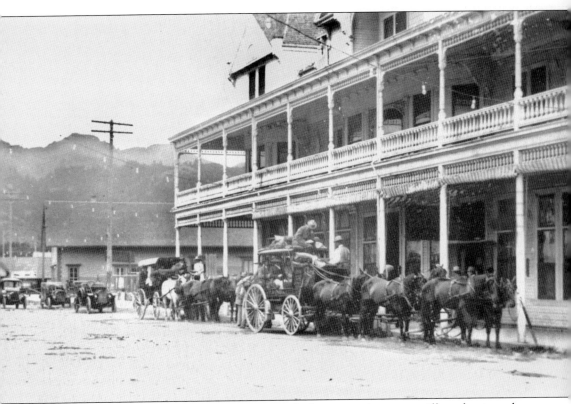

In the 1920s, when this photograph was snapped, the personal car was still predominantly a thing of the future. Nevertheless, drivers lined up to travel the treacherous highway through the mountain forest on Mount St. Helena to spend the day at Lake County resorts in Middletown, Lower Lake, and Clear Lake.

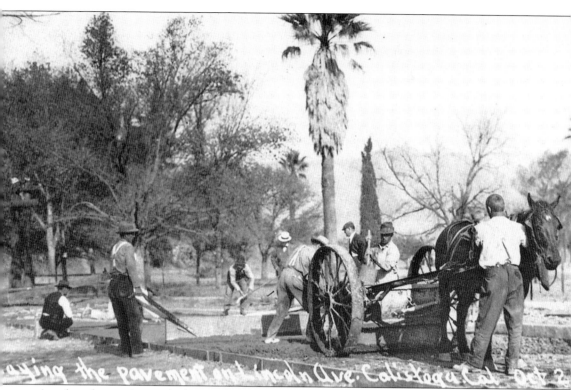

aying the pavement ont Lincoln Ave. Calistoga Cal. Oct 2

Another change that took place with the coming of the automobile is the paving of Calistoga's streets. Calistoga started paving its streets on October 25, 1923. This picture shows a crew working to lay the concrete along a stretch of Lincoln Avenue. Walking on pavement is more difficult for shoed horses, which certainly contributed to their diminishing use in town.

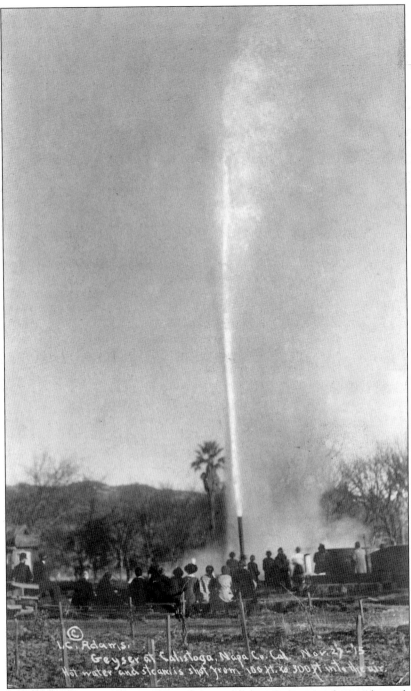

Long before white pioneers came along, Calistoga's Native Americans knew about the geysers like this one, just off what is today Tubbs Lane. Here a crowd watches the Old Faithful Geyser in November 1915. It is sometimes called California's Old Faithful, and it is one of the few geysers in the world that erupts at fairly regular 15-minute intervals, according to old-timers. They also state that when it erupts, the geyser throws 350-degree Fahrenheit water as much as 300 feet into the air, yet today's owners report it regularly reaching heights of up to 100 feet every 30 minutes.

With the coming of cars, fewer patrons used the passenger train, which started people speculating that perhaps Calistoga's glory days were coming to an end. The SP Railroad in November 1928 petitioned the state board of equalization that they be allowed to discontinue the passenger service to Calistoga. There were no Calistoga brass bands marking the final departure of the regular passenger train from Calistoga on July 13, 1929. Instead, it looks like there may have been about a dozen residents on hand for the occasion, not counting the two conductors to the left of the crowd (below). Of course, the local press was there. C. A. Carroll, owner of the *Weekly Calistogan*, is seventh from the left.

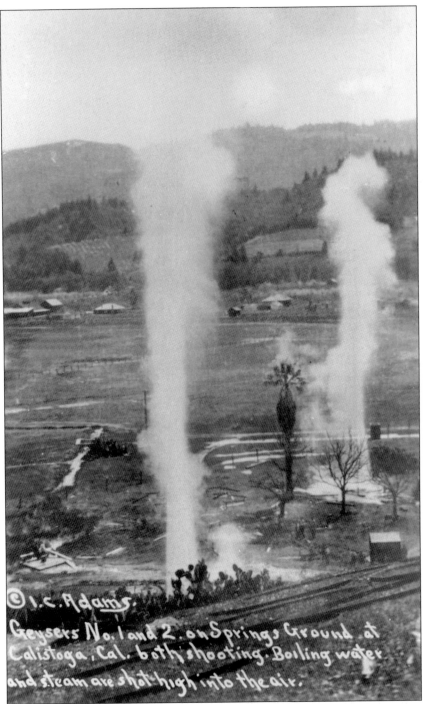

A pair of geysers at the springs grounds, the Indian Springs Resort today, shoot high into the air at temperatures hot enough to cook chicken. In 1928, they erupted almost constantly for several days before finally being brought under control by the Calistoga Fire Department. The only real damage, according to historian Burt Adams, was to the bathhouse. They also drained other wells in the vicinity.

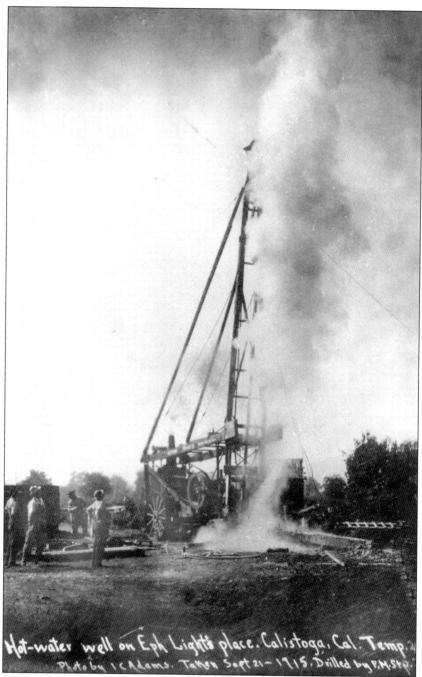

Hot-water well on Eph Light's place. Calistoga, Cal. Temp.
Photo by I C Adams. Taken Sept 21-1915. Drilled by F.M.Stp.

The hot geyser work being done here was to the hot water well at Ephraim Light's Grant Street property on September 21, 1915. The water coming out of this well is an exciting 220 degrees. It was sometimes argued that Light's original geyser was the first in the city, but the first may have actually been geysers at the Sam Brannan hot springs. Anyway, Light wanted his own hot water well to clean his wine barrels without building a fire each time. His driller went to about 150 feet and stopped—just short of reaching the water level. In the middle of the night, it was reported that the remaining few feet were blasted out by the high-pressure hot water.

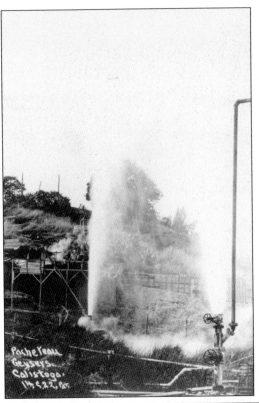

Another geyser at the springs grounds, at the time called Pacheteau's Geysers, erupted. When the geyser at the bathhouse burst out of the earth, sending equipment flying in every direction, a lot of press was generated, which was good for Jacques Pacheteau, who owned the place from about 1911. The news brought thousands of motorists for several days.

GEYSER INN, CALISTOGA, CALIF. E.T PLUMMER PROP

It is hard to pin down who actually "discovered" Calistoga's natural geysers on Tubbs Lane. Some sources say it was a grizzly bear hunter in 1847, while others say it was another explorer in 1870, but regardless of who discovered it, the natural wonder, which erupts about every 15 minutes, has enjoyed visitors as thrilled at the sight as Ephraim Light must have been when a geyser erupted on his land closer to downtown.

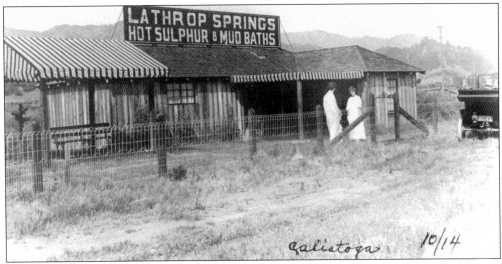

Someone named Lathrop built the first bathhouse on Washington Street in 1914 and sold it to a San Francisco mortician named G. Iaccheri. D. Aalders picked the property up after the mortician died and turned it into Aalders Hot Springs. Today that very first hot mineral bathhouse is known as the Calistoga Spa Hot Springs.

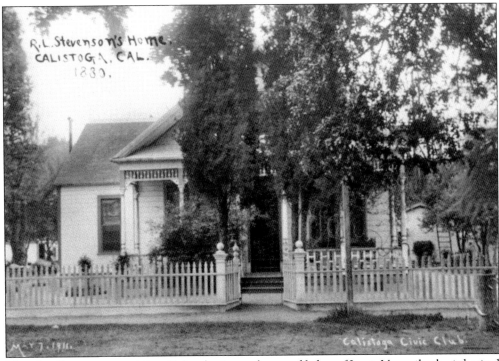

That San Francisco mortician, G. Iaccheri, was the grandfather of Louis Vermeil, who inherited the home on Washington Street not far from the spa. The house, a Queen Anne cottage from the 1880s, was part of a house built by a pioneer Calistogan named Henry Fowler. It was moved from its original Lincoln Avenue location to Washington Street and was briefly the home of *The Silverado Squatters* author Robert Louis Stevenson in 1880.

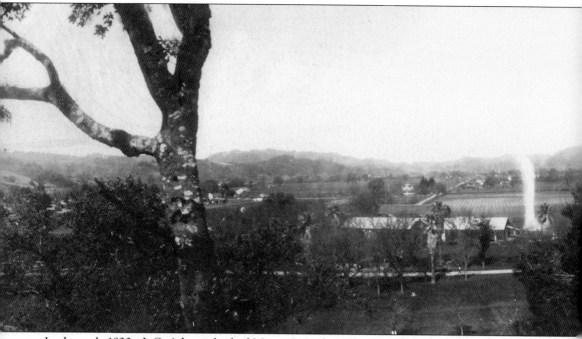

In the early 1920s, I. C. Adams climbed Mount Lincoln and captured this panorama of the flat land where Calistoga is situated in the Upper Napa Valley. In the very center of the landscape,

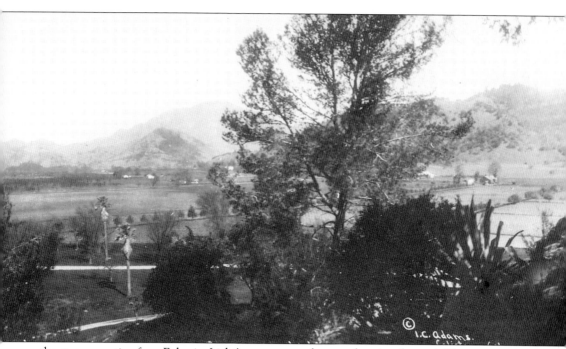

the geyser spouting from Ephraim Light's property can be seen shooting skyward. The temperature of the water coming out of that spout is recorded as being above 212 degrees.

Not far from Calistoga is another natural wonder that has attracted tourists since the early days of the city. It is the remains of a forest turned to stone: the Petrified Forest. Discovered in 1870 by "Petrified Charlie," a person profiled in minute detail in *The Silverado Squatters* by writer Robert Louis Stevenson, who marveled that Charlie could actually get a half-dollar from visitors who had endured the difficult task of even getting to the place 5 miles west of Calistoga in the Mayacamas Mountains. Here a family rests on one of the giant stone trees.

A visitor to the Petrified Forest west of Calistoga on Petrified Forest Road gets an up-close and personal look at one of about a dozen three-million-year-old trees, excavated between 1910 and 1920. The Petrified Forest was designated State Historical Landmark No. 915 in 1978.

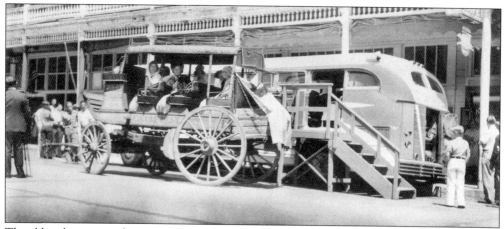

The old and new eras of transportation in Calistoga converged in a single event on June 17, 1938, in front of the Hotel Calistoga. Stagecoaches and other wagons driven for so long by Bill Spiers or one of his hired drivers no longer rattled to a stop in a mighty cloud of dust downtown. The coaches were replaced by large autobuses like Spiers's "Bull Moose" before more stylish vehicles like the Greyhound Bus made their mark. Not long after Greyhound started its service to Calistoga in 1938, the bus company featured its newest bus in an open house–style ceremony downtown during which the old mud wagon dubbed "California" was rolled out of storage by the Native Sons of the Golden West and posed beside the new bus. Young Betty Decker, who had just graduated from Calistoga High School, was chosen to christen the new bus "The City of Calistoga." Inside the bus design included many pictures and notes on Calistoga history. In early 2008, the young lady in the image below, Betty Decker Hardison of El Cerrito, California, recalled that day seven decades prior. "It can't believe it's been 70 years!" Pictured from left to right are former Calistoga Chamber of Commerce director Dr. E. J. Stevens, director of the local bus line Thomas Lyle, the lovely Betty Decker—as she was described by the *Weekly Calistogan*—and commentator and radio personality A. W. Scott, who conducted the "Romance of the Highways" radio program for the Pacific Greyhound Lines. Decker's parents owned the old Decker Electric Shop, located where the Wappo Bistro is today. Her grandfather was Porter Decker, a former driver for Spiers and the water sprinkler wagon featured in this volume.

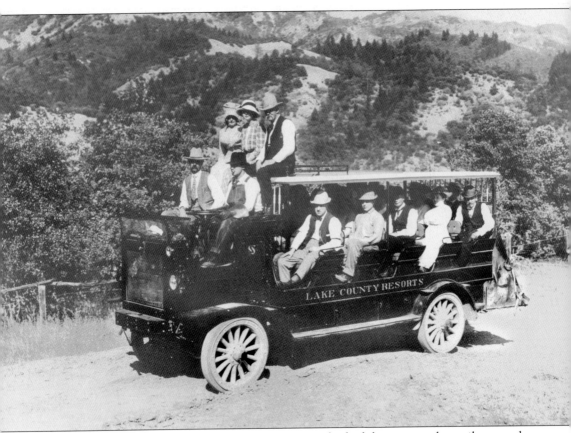

Even before the new bus rolled into town, Bill Spiers, who had driven countless miles over the passes and mountain roads, had purchased what the newspaper called a "bully fine automobile stage." He started his autobus experiments with a five-passenger vehicle he called "Old Sally" before going to this bigger truck he called the "Bull Moose," which could carry 20 passengers with reliable service and excellent comfort.

This Calistoga Library image was snapped shortly after the building opened in 1924. It is interesting to note that the week it opened to the public, the library, which was built by the Calistoga Civic Club and doubled as a meeting place for the club, opened with a parade that included a couple hundred members of the notorious Ku Klux Klan. At the opening ceremony, the Klan donated a large Holy Bible to the library to commemorate the event. A report in the local newspaper of the time, the *Weekly Calistogan*, said the members of the Klan signed the Bible; recent attempts by historians to locate that book have proven fruitless.

In the mid-1920s, this old parlor looked as comfy as one's own home, but instead of being someone's anteroom or den, it was the Calistoga Library at the corner of Myrtle Street and Lincoln Avenue. It was also home to the Calistoga Civics Club.

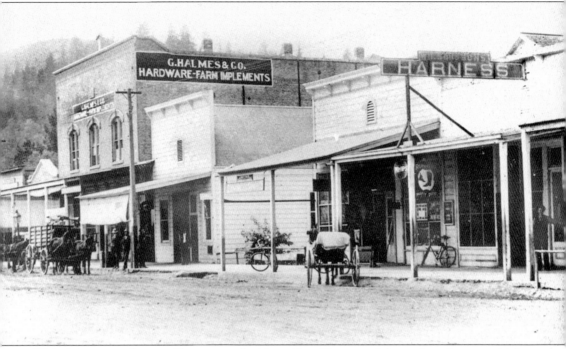

With the coming of cars and busses, new buildings like a library, and the paving of streets, which started in 1923, shots such as this of Lincoln Avenue in 1898 with its Wilson and Sons Harness and G. Halmes and Company Hardware were quickly becoming images of yesteryear, a past most newcomers and the very young could not recall. This is the stretch of Lincoln Avenue looking west toward Foothill Boulevard, once called Main Street.

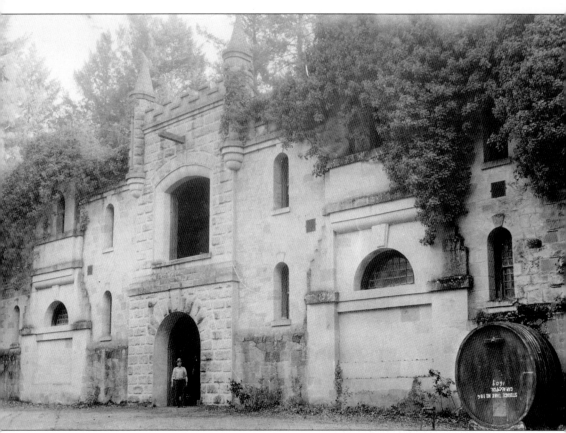

A winery worker is dwarfed standing in the doorway of the winery built by Alfred Tubbs in the 1880s on Tubbs Lane. The facility was taken over by Tubbs's son and produced wine for cooking, vinegar, and other products. It changed owners and reopened in 1924, during Prohibition. Of course, now the Jim Barrett family, who produced the chardonnay that put Calistoga and California wine on the international viticulture map, owns it.

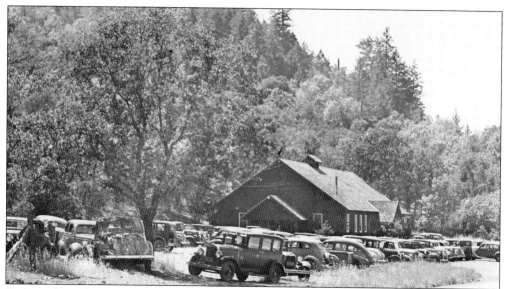

Built in the early 1920s, the Tucker Farm Center today is much the same as it was when it was new, as in this picture. It continues to be a location where business conferences and weddings are held. There were often weekend dances here, and lately it has become a center for the theater arts, featuring local residents in re-creations of theater classics by Shakespeare and more contemporary plays like *The Vagina Monologues*.

The Calistoga National Bank was the second bank in Calistoga, built in 1921. Later owned by Bank of America, it represents the only neoclassical architectural–style building in Calistoga. Bank of America moved out in 1961, and the building has housed several businesses since, the best possibly being Bella Tootsie, an excellent shoe store that has kept the original decorative ceiling moldings.

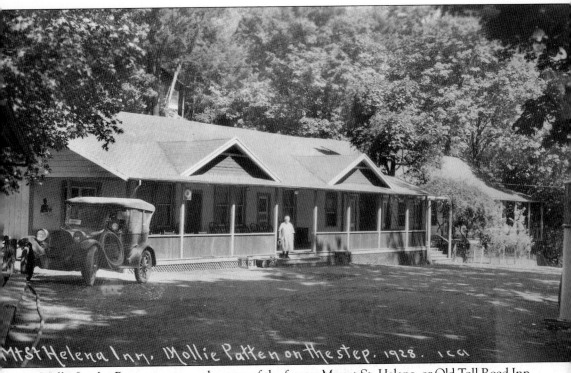

Mt St Helena Inn, Mollie Patten on the step. 1928. ica

Mollie Lawley Patten pauses on the steps of the former Mount St. Helena, or Old Toll Road Inn. She succeeded her brother Charles Lawley in operation of the inn and tollgate when her husband passed away. Mollie was one of the first graduates of Mills College. Robert Louis Stevenson wrote about life at the house when he stayed here in 1880 on trips up and down the mountain.

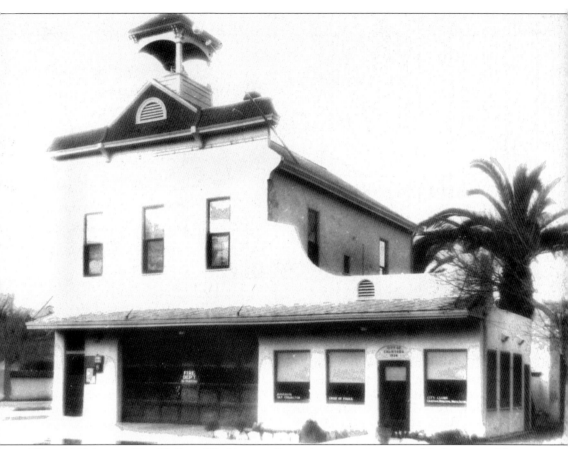

The old Calistoga City Hall on Washington Street is seen as it appeared before remodeling took place in 1992. It was previously a library and a firehouse. After the 1901 fire, though, the Badlam's Opera House stood here. It burned down. The building is located at Washington and First Streets. Across First Street, to the left of the building, is the Roman Spa today, but it was the location of William Spiers's stable in the early 20th century.

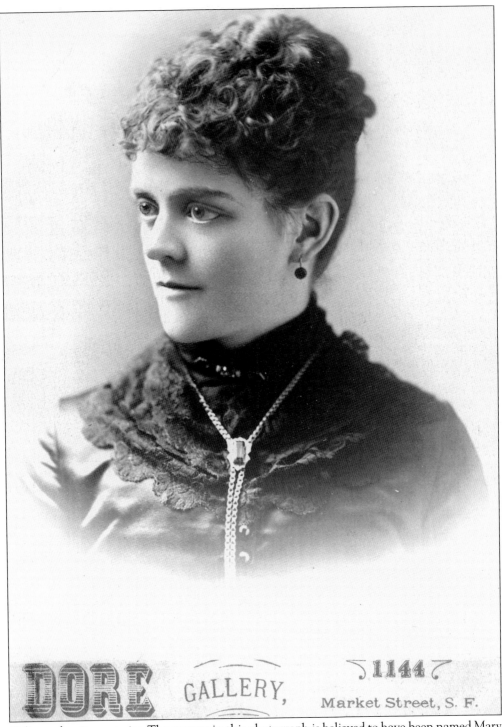

DORE GALLERY, ⸏1144⸌ Market Street, S. F.

Calistoga has its mysteries. The woman in this photograph is believed to have been named Mary Gisford. On the reverse side of this picture is the inscription, "Compliments of Mary, Mollie and Mr. Patten." It is dated August 26, 1884, but what makes this picture an exciting mystery is that it was found on a trail near the old tollhouse near Calistoga in 1954 by Mary Talbot.

After hauling in a wagon filled with crates of grapes, these workers appear to be ready to take a short break from their workday. The worker wearing the apron in front appears to be holding a plate of food and an old-fashioned lunch bucket.

Downtown Calistoga was loaded with bargains in the 1940s—ground beef at 30¢ per pound, toys for 35¢, and brownie mix for 52¢. And with the changing styles of cars, downtown began looking much like it does today.

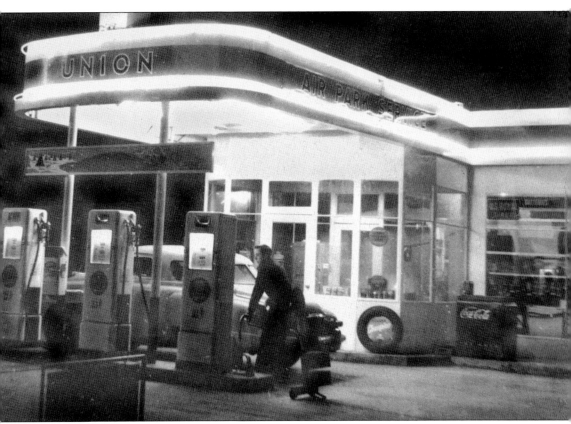

Air Park Service Station was a well-lighted place to fill up the gas tank in the mid-1950s, as Mr. Oberg, the man filling up a customer's car, could attest. This photograph also ran in the 1953 Calistoga High School yearbook. Visitors to Calistoga today will find the Calistoga Chamber of Commerce on the site where this, the Air Park Service Station, once stood. It was called Air Park Service because it once stood at the Gliderport, where small planes would take off regularly with glider planes in tow.

The Calistoga Hospital was once the home of James H. Francis, who owned a mercantile store at the corner of Lincoln Avenue and Washington Street. He is also known to have owned a few ranches in the area. He passed away in 1891, but his house lived on as a fine little hospital from 1918 through 1964. There are still local residents who say they were born here. In the last two decades, it has become Calistoga's worst eyesore, but in January 2008, new owners Neal and D'Nyse Schafer from Napa started to restore the property and hope to have a fine bed-and-breakfast by 2013. This photograph was taken around 1937.

Calistoga's people have always been proud of their pioneer heritage. Far less than 100 years after the Mexican land grants opened the floodgates for the descendants of Northern Europeans, Calistogans were already dressing up like great-grandma and great-grandpa to celebrate. This picture, taken in June 1935, includes, from left to right, a Mr. Tedeschi, Helena Piver, Ed Light, an unidentified woman, and Judge Winkleman.

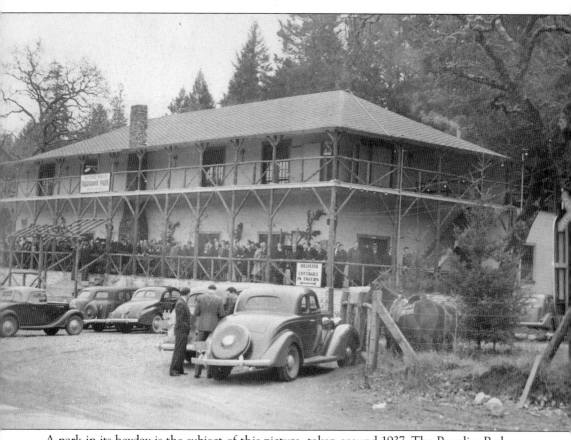

A park in its heyday is the subject of this picture, taken around 1937. The Paradise Park was a very popular place to have a dinner and dance and was located approximately where Bothe State Park is today. The property once belonged to Lillie Hitchcock Coit, benefactor of the Coit Towers in San Francisco. The Bothe brothers owned Paradise.

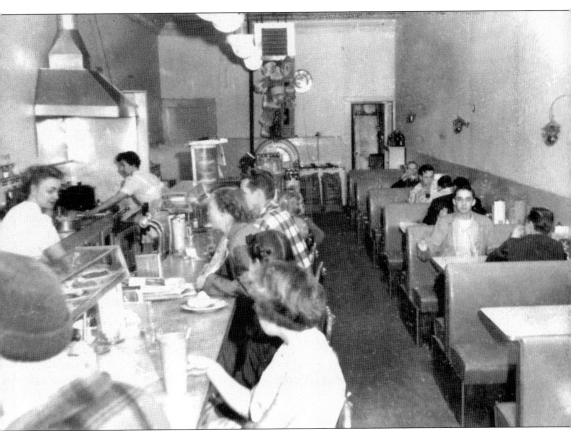

Back in Calistoga, one of the most popular places for the locals in the 1940s and 1950s was the Silverado Creamery, which is today called the Calistoga Bakery and Creamery. It is still in the same building, although a lot of renovations have occurred. Still, many similarities to this photograph continue to exist.

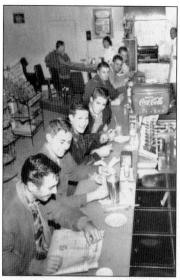

Another popular place in the changing days of Calistoga was Rigby's Village Green. It would be hard to recognize in today's Calistoga because it was located where the high-end Brannan's Grill is today. One old-time resident who frequented Rigby's as a teen remarked that the soda fountain had a well-stocked jukebox that was always playing, and if one wished, he or she could get up and do some dancing.

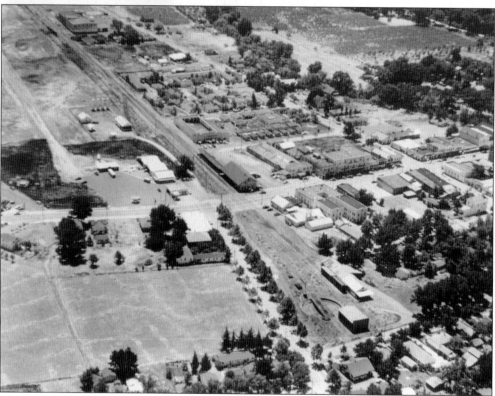

This rare picture was taken from a plane high above Calistoga in the 1960s. The very center of the image shows the Calistoga train depot, minus the train cars there today. Across the street where the local supermarket is today is an entirely different building. The Fair Way Trailer park isn't there. Find the Hotel Calistoga, with its three stories. The most interesting feature is the railroad, though. The tracks come from the top left of the picture and stop near the right bottom at a round circle, which was the table where railroad engineers used to turn the trains around. In old Calistoga, the street along that track was once called Railroad Street; today it is Fair Way.

In this final picture of the Hotel Calistoga, taken in the early 1950s, a boy is riding his bicycle down the middle of Lincoln Avenue and into Calistoga's future. The stately old Hotel Calistoga, today known as the Magnolia Building in honor of the hotel that was located there prior to the 1901 fires, looms above the street. It would soon undergo renovations that would remove its upper, third story.

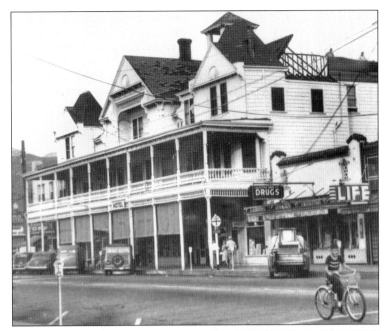

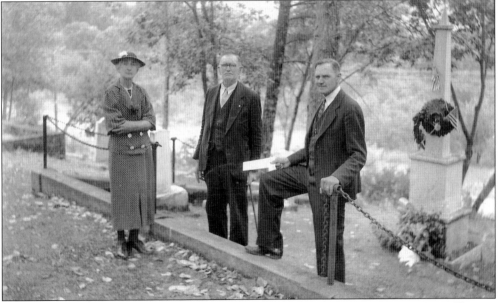

Just in time for Memorial Day, on May 30, 1936, the owner of Pioneer Cemetery, Anna Hopper, turned over stewardship of the graveyard her father, S. W. Collins, established in the 1870s to the City of Calistoga. Representing the city here is Mayor Charles Butler and C. L. Petersen. It was the second cemetery in Calistoga, the first being located on what is today Highway 29 northeast of town between Mora Street and Lake Street, according to an 1868 map of the then fledgling community. Early on in Calistoga's history, the dead were mostly buried on small family plots on their own property. One example of that is the Cyrus family, who were buried on their property behind the gasoline station at today's Petrified Forest Road and Highway 128. Although the headstones are still there and can be seen from the Highway 128, the family was moved to Pioneer Cemetery.

ACROSS AMERICA, PEOPLE ARE DISCOVERING SOMETHING WONDERFUL. *THEIR HERITAGE.*

Arcadia Publishing is the leading local history publisher in the United States. With more than 4,000 titles in print and hundreds of new titles released every year, Arcadia has extensive specialized experience chronicling the history of communities and celebrating America's hidden stories, bringing to life the people, places, and events from the past. To discover the history of other communities across the nation, please visit:

www.arcadiapublishing.com

Customized search tools allow you to find regional history books about the town where you grew up, the cities where your friends and family live, the town where your parents met, or even that retirement spot you've been dreaming about.